the ART of CHALK

Techniques & inspiration for creating art with chalk

TRACY LEE STUM

ROCKPORT

Quarto is the authority on a wide range of topics.

Quarto educates, entertains and enriches the lives of our readers—enthusiasts and lovers of hands-on living.

www.QuartoKnows.com

© 2016 Quarto Publishing Group USA Inc.

First published in the United States of America in 2016 by
Rockport Publishers, an Imprint of
Quarto Publishing Group USA Inc.
100 Cummings Center
Suite 406-L
Beverly, Massachusetts 01915-6101
Telephone: (978) 282-9590
Fax: (978) 283-2742
QuartoKnows.com
Visit our blogs at QuartoKnows.com

10 9 8 7 6 5 4 3 2 1

ISBN: 978-1-63159-066-5

Digital edition published in 2016
eISBN: 978-1-62788-656-7

Library of Congress Cataloging-in-Publication Data available

Design: Traffic Design Consultants
Cover Image: Traffic Design Consultants
Page Layout: Megan Jones Design
Photography: Michael Moore, PlanetMoore

Printed in China

*This book is dedicated to all those artists—
past, present and future—
who choose the path less taken
in search of personal artistic truth.*

CONTENTS

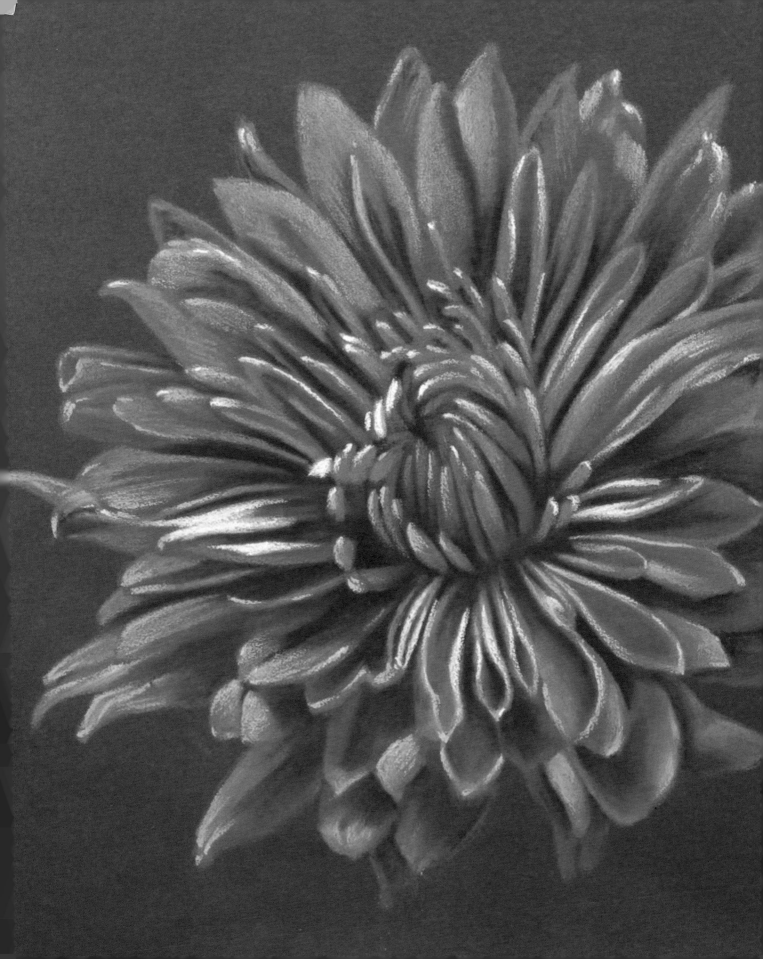

PREFACE

The Art of Chalk is for those inquisitive artists who would like to venture into new and unfamiliar territories of creativity involving chalk, pastels, and other mediums used to create chalkboard art, pastel painting, and street painting. It's also for those who have taken the plunge into these art practices and would like a clearer understanding of how the creative process works for accomplished artists in each of these areas.

Many artists have a will and desire to explore these art forms but don't know where or how to begin. My aim is to provide inspiration, guidance, and instruction, and to demystify these processes by offering the tools, methods, and tips that will assist and inspire you in your art-making exploration.

The Art of Chalk is also intended to help you navigate some of the surprises that may come with working with these mediums. When I began street painting many years ago, I had to figure all of that out on my own, first by simply participating then, thankfully, through the generous sharing of information by my peers and colleagues. Street painting found me, as if by accident, so I wasn't fully prepared for what was to come—the long hours sitting on hard pavement in the heat, the ephemeral reality of a lost drawing when the rain suddenly let loose, or the energy of the crowds of thousands who came to see our work.

So here is one road map that takes you from idea to finished work, ideally with confidence and ease. And who knows? With practice, application, and concentration, perhaps a new masterpiece is waiting to be revealed.

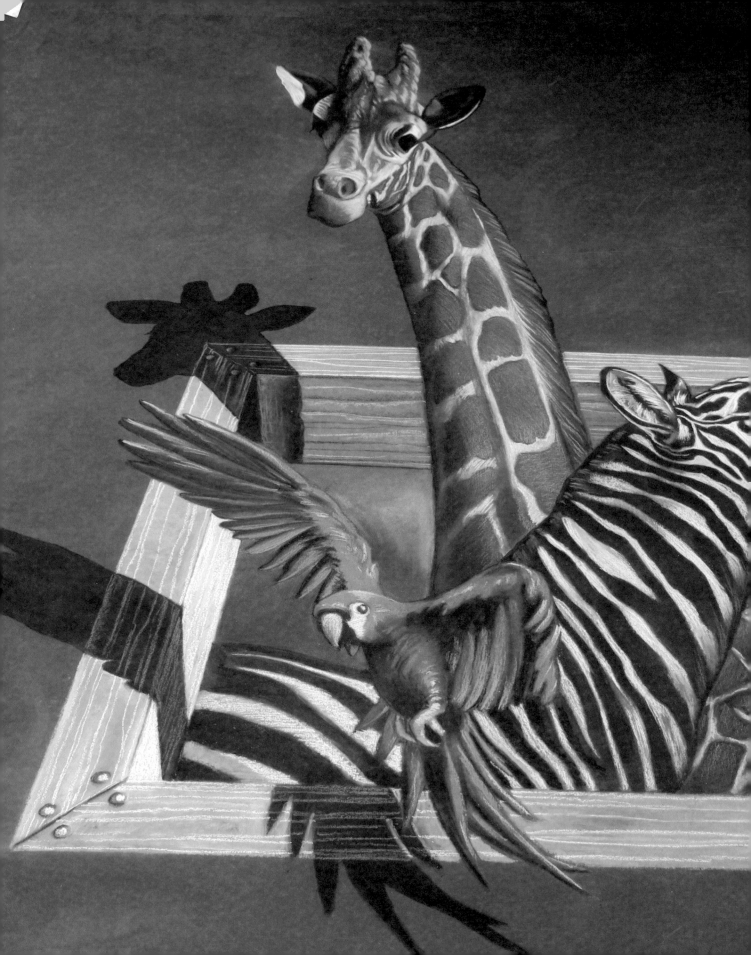

1 THE ART OF CHALK: AN OVERVIEW

You've probably seen various types of chalk or pastel artwork in your journey through everyday life, either on a street, in a restaurant, on a sidewalk, or in a museum or gallery. Artists have been "playing" with chalk for centuries. And yes, I say "playing," as this medium most certainly allows for some very free expressions of creativity.

"FINDING STREET PAINTING WAS LIKE FINDING MYSELF. IT IS THE MOST FREEING CREATIVE EXPRESSION THAT I HAVE EVER ENGAGED IN. NEVER MIND THAT IT'S CREATED ON PAVEMENT!

IF SOMEONE HAD TOLD ME TWENTY YEARS AGO THAT I'D BE DRAWING ON SIDEWALKS FOR A LIVING I WOULD HAVE LAUGHED AT THEM. WHO WOULD HAVE THOUGHT THAT CHALK ON PAVEMENT WOULD HELP ME REALIZE MY POTENTIAL AS A VISUAL ARTIST?"

—TRACY LEE STUM

Mini Zoo **by Tracy Lee Stum.** Even when given only a small area in which to work, a 3D chalk image can be very convincing when designed and shaded effectively.

No longer thought of as just a schoolroom tool, chalk has come into its own with the advent of new and fascinating applications. These days one may see chalk art in a home, on the exterior of a building, or spanning a sidewalk as big as a football field.

While pastelists continue to exhibit their works in galleries and museums, some chalk artists have moved their delicate art form outdoors, with street painters creating works on pavement that are subject to the conditions of an external and often unforgiving environment, and chalkboard artists creating works in public environments such as retail shops, restaurants, interior spaces, and even on the sides of buildings. What's really fascinating about these artworks is that the ephemeral quality of the medium is not only embraced but also celebrated. Some may not last very long at all, but they do inspire, illuminate, and demonstrate the nature of creativity in all its temporal glory.

CHALKBOARD ARTISTS: THE DESIGNERS

Who hasn't written on a blackboard at some time in his or her life—to solve an equation, demonstrate a scientific formula, elaborate on a historical discussion, or repetitiously copy an "I will not" punishment statement over and over? We think of a blackboard as a teaching tool, which it most certainly has been, but today we see the evolution of a new art form that treats the chalkboard as a contemporary canvas.

Once the domain of professional sign painters who created unique commercial displays with ornamental fonts, chalkboard art can now be seen in all sorts of locations, from restaurants and retail shops to corporate offices and marketing events. Chalkboard artists are also embellishing well-dressed home interiors and, in the case of Dana Tanamachi, a well-known graphic designer widely recognized for pioneering the current chalkboard art trend, creating their own home decorating product lines for retailers such as Target and West Elm. The popularity and appeal of chalkboard art have been rising worldwide, as is evident on various social media sites such as Pinterest and Instagram. New designs, new font interpretations, and new approaches are growing exponentially.

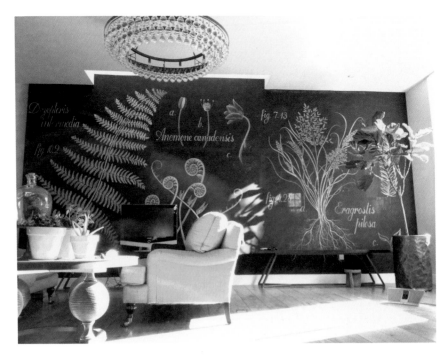

Today's chalkboard artists are, in many cases, designers first. They share a fascination with and an appreciation for typography and historic graphic styles. They turn to the chalkboard to create pleasing compositions that are also often pragmatic and functional. One may think their creative process is restricted, constrained by content and structure, yet the level of detail and inventiveness within these works make it clear that such limitations can actually be quite liberating. These stylistically adept designer-artists offer up delightful and pleasing ephemera to enhance our everyday lives.

Catherine Owens used botanical motifs to transform an ordinary wall into this room's focal point.

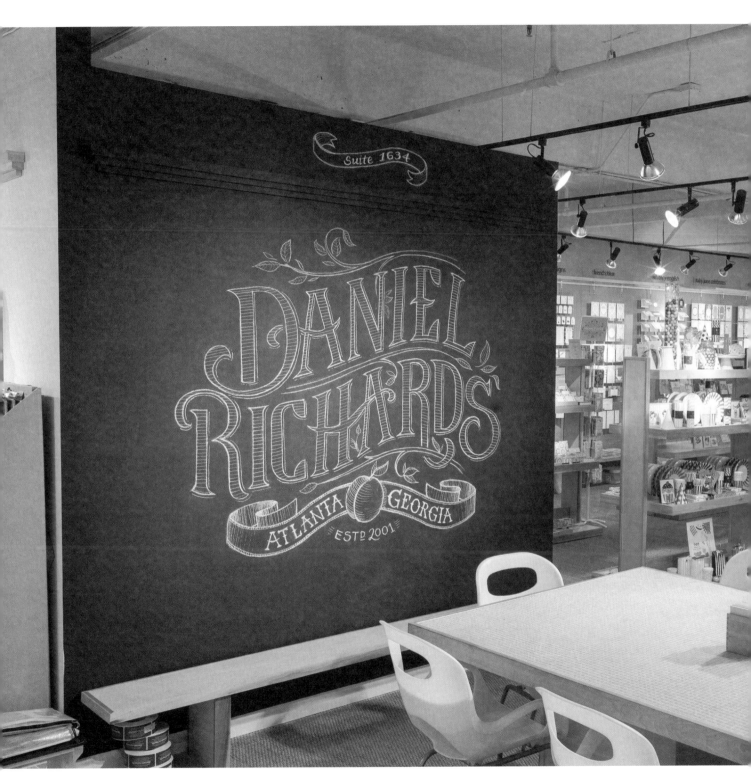

Perfect for this retail location, Chris Yoon's chalk-board logo design works well with the shop's creative and inviting environment.

Maggie Choate's words to live by in chalk.

Bryce Widom's imaginative portrait hints at other-worldly places by referencing Japanese stylistic elements.

PASTEL ARTISTS: THE OBSERVERS

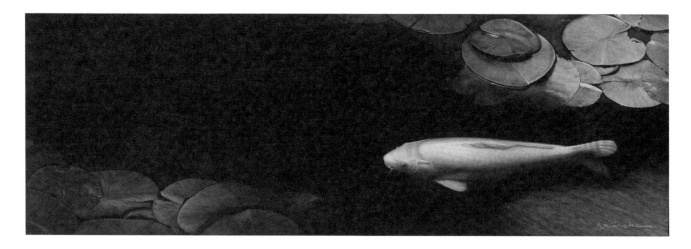

Portraits, landscapes, still lifes, and figurative works: these realistic subjects are associated with the classic working motifs of gallery and museum artists around the world. Pastel artists straddle painting and drawing, yielding works that appear to be paintings yet are created through drawing directly on a surface with pieces of highly pigmented dry color.

The term *chalk* technically refers to a soft, white, porous, sedimentary carbonate rock that is a form of limestone. In art circles of antiquity, chalk was available in three mineral colors: white (calcium carbonate), red or sanguine (a mixture of iron oxide and clay), and black (a mixture of carbon and clay). These chalks could be used in their natural state to make marks on canvas, paper, or a chalkboard. Today's commercially made chalk contains high quantities of calcium sulfate mixed with a binder, which makes for a harder and more brittle product.

Although pastels are handled similarly to chalks, and are often used alongside them by both chalkboard artists and street painters, their makeup is slightly different. Pastels are a combination of organic and inorganic ground pigments that are mixed with a binder to create a stick of pure, concentrated color. Due to their high volume of pigment and small amounts of binder, they tend to deliver much richer and more vibrant color as compared to traditional chalk. Tints, tones, and shades may be created throughout the color spectrum, often marked by a velvety or buttery texture when applied.

The pastel artists featured in this book are observers. Their dedication to study, practice, technique, and execution are the hallmarks of their work as they strive to capture their investigations and discoveries successfully. Understanding their medium and using it to the fullest of their abilities exhibits the maturity of hours spent immersed in the art form. Brilliantly captured sunsets, fleeting expressions on a face, light glinting off an object, the elegance and grace of the human form—these subtle details and challenging effects are adeptly handled by the skillful and patient pastel artist.

Otto Stürcke's tonal drawing beautifully translates the tranquility of a fish gliding through mysterious waters.

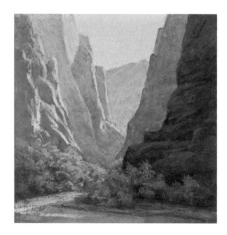

Gary Huber's naturalistic composition gives us a glimpse into a specific place and time through the capturing of light and color in this landscape.

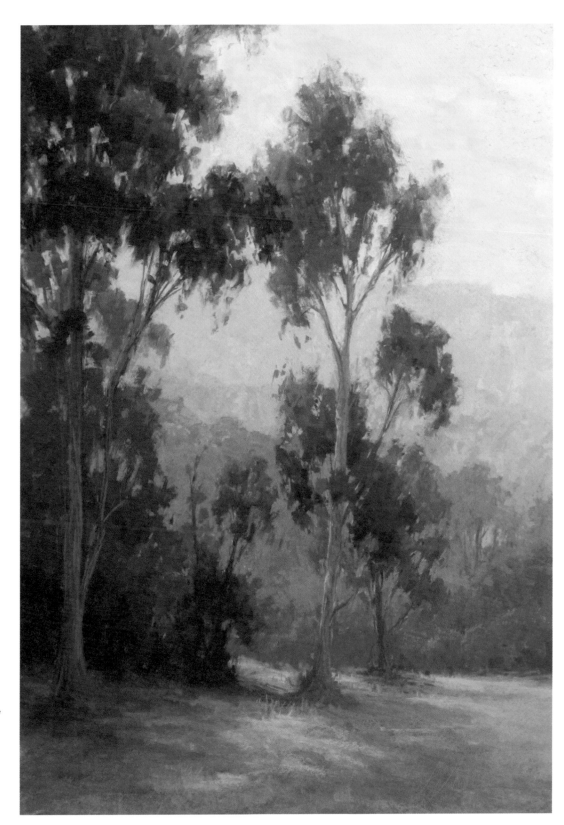

Kim Lordier is inspired to see below the surface and focuses on the abstractions of the world around her. In her investigations of natural landscapes she searches for a deeper understanding of light and dark through shape, form, and patterning.

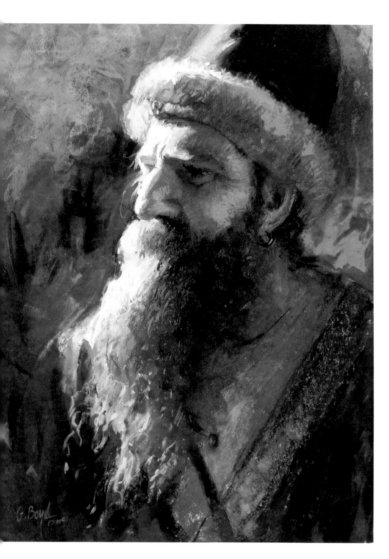

Vibrant color, a direct lighting source, and a textural application of chalk are explored in this portrait by Gerald Boyd.

Untitled (Fab II). Artwork by Ryan Bradley.

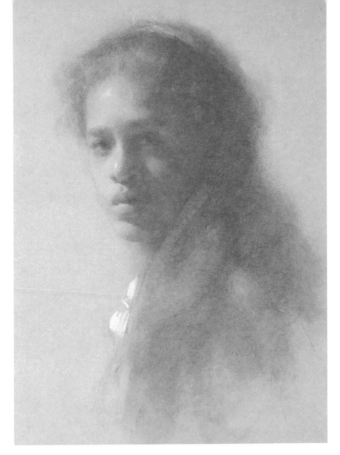

***Young Girl from Guatemala* by Susan Lyon.**
Understanding the nature of light and shadow is an
age-old problem that many artists, including pastel
artists, seek to solve. Lyon is moved by the way in
which light hits a face or by an individual's
personality.

Cuong Nguyen falls in love with the human face—its
expressions, its variations, and its mysteries. Perhaps
he is looking into the soul of his subjects as he strives
to recreate the beauty and mysteries inherent in
each individual.

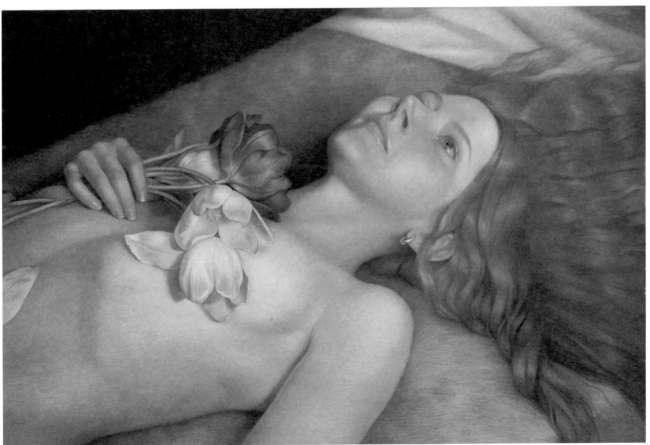

STREET PAINTERS: THE PERFORMERS

Pastel on pavement seems like an unlikely pairing, yet this combination of medium and surface has yielded some of the most amazing ephemeral works seen in the twenty-first century. Street painters take chalk, pastel, and any other dry medium to pavement, sidewalk, plaza, or other urban trafficked location to make their works. A spectator might view it as a daunting undertaking, with environment, weather, pedestrians, traffic, and all sorts of other elements potentially impeding the process, but street painters know the joys and benefits of creating such fragile work, despite the odds of its survival.

Often bold in character, street painters are in many ways performers. They relish sharing their creative process. These works are created over the course of a few days in full view of the public, and passersby are often curious about the creative process, which with street painting they can see in action. That often sparks interaction between artist and observer, who may ask: What is the street painter drawing? Why is he or she drawing it? How long will it last? What happens when it rains?

For many street painters, the infusion of energy generated by working in public is a core motivation for practicing the art form. While most traditional art forms are practiced in a studio, which can be isolating in some ways, street painters use the outside world, creating a dynamic not often found in the visual arts. Street paintings share an affinity with Tibetan sand paintings, live music, and theatrical performances, all of which are created in the

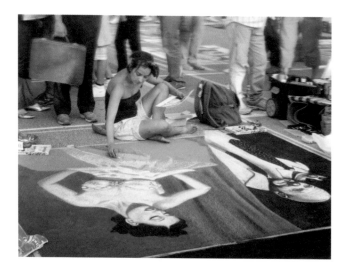

Artist Valentina Sforzini seems oblivious to the movement on the busy walkway behind her.

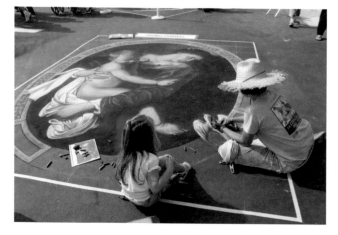

Crowds, which tend to form around street painters as an image "magically" appears out of thin air, are part of working in public. Sometimes the public wants to get up close and personal, especially children. I'm shown here during the early days of my street painting career.

moment and exist briefly but beautifully for the viewer's consideration. These paintings may not last long—a few days at most—yet the wealth of experience they offer for both artist and viewer is something quite extraordinary.

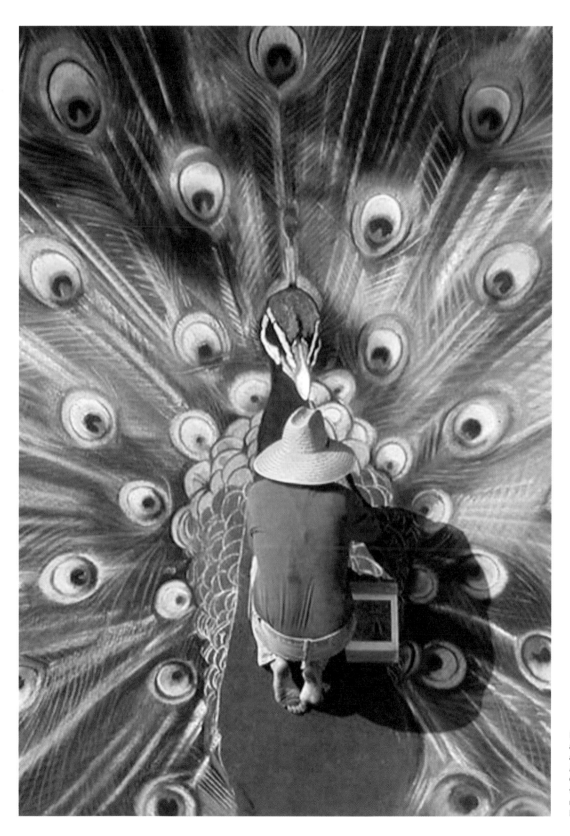

Rod Tryon working on a resplendent peacock at the Santa Barbara I Madonnari Festival in California. Roughly translated, *madonnari* means "painters of Our Lady" in Italian.

This ethereal painting of a mermaid by artist Ketty Grossi transforms the block pavement into a sea of light and color.

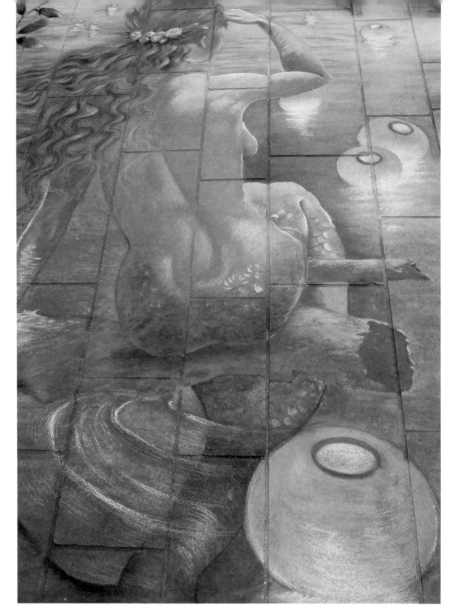

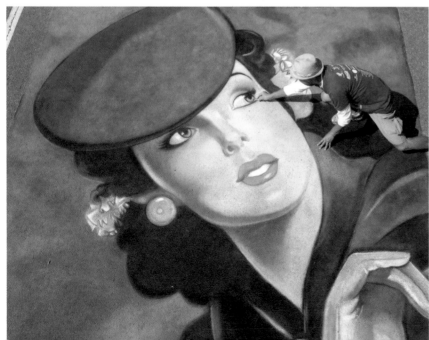

Joel Yau putting the final touches on a retro-themed portrait. Large portraits are always a crowd-pleaser at street painting festivals.

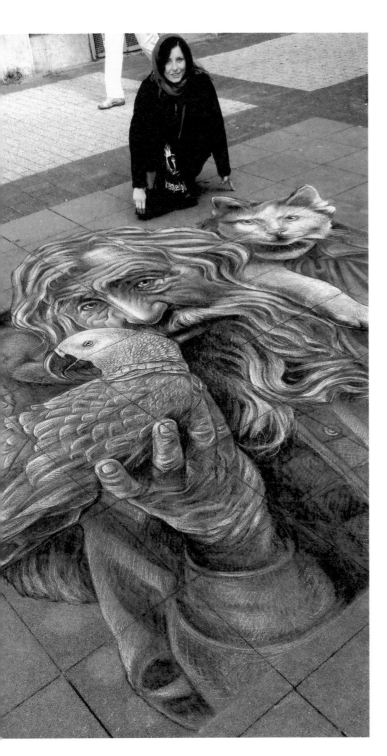

A fan of classic cars, Julio Jimenez created this montage of American cultural icons, Batman and Robin, with the Batmobile being the centerpiece.

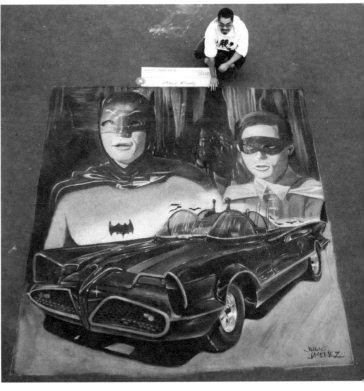

Vera Bugatti's original designs demonstrate a masterful understanding of composition, color, and chalk application.

2 CHALKBOARD ART

Whether on paper, pavement, or chalkboards, the breadth of artistic individuality expressed with chalk pastels is limitless, as illustrated by this example of work from artist Bryce Widom.

Today's chalkboard artists exhibit skill, savvy, and expertise in transforming an ordinary, rather mundane surface into a unique vehicle for type and image, both often laced with elegance, whimsy, humor, and beauty. These artists make commercial and creative works with a very simple palette, frequently using a black ground and only white chalk, with other colors sometimes thrown in for fun.

"I LOVE THE TEMPORALITY OF THESE WORKS, AND EMBRACE THE CHANGE AS I DO THE CYCLING OF THE SEASONS."

—BRYCE WIDOM

Chalkboard art is typically defined by its use of chalk or chalk markers, either on a blackboard or on a surface that emulates one, and it often features fonts highlighted with illustrated details.

Alternately we now also see murals and elaborate decorative designs emerging on retail chalkboards as well. Chalkboards are, in essence, blank canvases where imagination sets the rules.

INSPIRED BY FONTS

One of the recurring features in chalkboard art is the use of typography as a central design component. Typography is typically an essential element in communicating an explicit message, especially in commercial works, and each artist works diligently to develop his or her own unique visual language. Clarity, legibility, aesthetic harmony, and visual elegance are hallmarks of many successful chalkboard creations, regardless of style. Many emerging artists today are inspired by historical styles, so they've tapped into the methods of the past with a twist, creating elegantly designed signage and messages that are easy and effortless in appearance. Always eye-catching, these works may even convey messages of intent and awareness to give pause to an otherwise busy day.

Menu boards with a nostalgic feel are popular, but so are big statements with lots of flourish. Typically, ornament often wins out over basic Helvetica; the featured script sets the tone of the overall design aesthetic. These elaborate fonts are rendered with flair and accuracy. Think of scripts and cursive styles from the seventeenth through the early twentieth centuries, but modified to work with chalk. Using a font as the basic design component, the artist may embellish with borders, illustrations, and graphic details to complete the concept. A steady hand, a knack for scale and proportion, and the ability to visualize an organized composition are requirements for chalkboard artists, many of whom work from simple sketches yet execute their work freehand (see page 46 for more information).

Catherine Owens's retro-style piece looks like a remnant from the early twentieth century.

Because their work is often graphic and ephemeral, chalkboard artists may find focused inspiration for works in some very specific places: literature (particularly about inspiring individuals), music, books (old typography and sign painters' visual reference books), old signs, typography painted on buildings, historical graphic design sources, Victorian and twentieth-century art styles, and ephemera. No matter how inspiration strikes, whether through research or imagination, artists need it to keep their creative minds and hearts thriving.

This colorful menu board by Brendon Pringle demonstrates a variety of fonts and illustrations in an elaborate layout.

Nigel Eaton loves the current revival of hand lettering in all its forms, and looks to traditional sign-painting books as inspiration for composition, letter formation, and style.

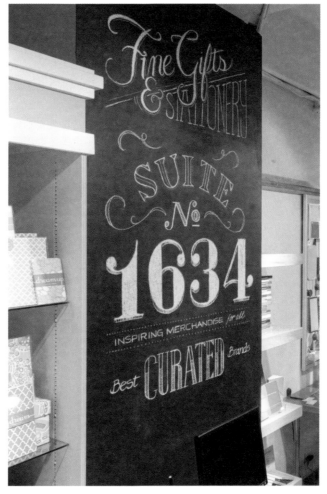

Chris Yoon draws inspiration from books and printed ephemera, old signage, lettering painted on the exteriors of buildings—just about anywhere he can find lettering styles.

FEATURED IMAGERY

Of course, visual inspiration for chalkboard artists can come from myriad sources. Here we consider two types—general artistic inspiration and focused inspiration—for the creation of a specific work of art, whether commercial or personal.

When referring to general inspiration, some artists may find their everyday surroundings as adequate. Maggie Choate bears in mind T. S. Eliot's famous quote from his essay on British dramatist Philip Messinger: "One of the surest tests [of superiority or inferiority] is the way in which a poet borrows. Immature poets imitate; mature poets steal; bad poets deface what they take, and good poets make it into something better, or at least something different." While looking to others' art for inspiration and motivation, she also takes great pains to make sure her work is original and reflects her own aesthetic.

Catherine Owens finds impermanence and movement in the natural world inspiring. Since chalk is a fragile medium, by its nature fleeting, she is moved to mirror this transient quality by depicting tiny ephemeral movements in her art.

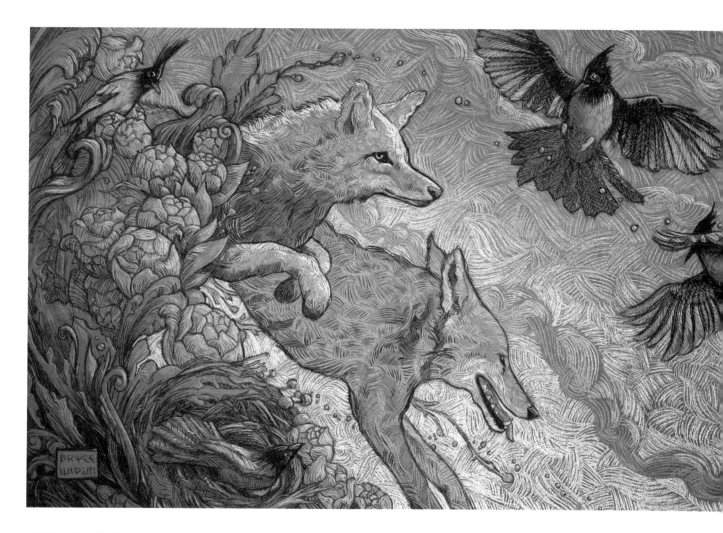

BIRTH OF AN ART FORM

Demonstrations of black-and-white chalk art first emerged in the 1980s, when American artist Keith Haring began creating chalk drawings in the subway spaces of New York City. Haring was arrested for his public works, which were considered vandalism at the time, despite the fact that they were often temporary. While not centered on specific typography, Haring's iconic works reflect the artistic style of his time, illustrating his views on society.

Current chalkboard art trends began developing as a movement in 2009, when artists put a unique spin on traditional forms of signage, enhancing the presentation of decorative menu boards and café announcements made with chalk on chalkboard with a return to past centuries' use of elaborate script-style fonts.

A poet at heart, Bryce Widom observes the cycling of the seasons: spring's blossoms, summer's thrumming heat, the golden still point of late summer, the letting-go of autumn's darkening days, the deep silence of winter, feeding right back into the blooming of spring. He also credits the exquisite skill of other artists who have mastered their media.

GATHERING INSPIRATION

Each artist has his or her own method of accessing material for developing designs and images. Some considerations for concepting a design will reflect a work's specific application. For example, when creating a piece for a retail shop—a stationery store, perhaps—fonts, book covers, and classic banners may be considered. An artist who's designing a menu board would certainly research the foods and dishes listed and perhaps incorporate related motifs.

With the help of sketches, doodles, and photography—both their own and reference images viewed online—chalk artists work out their own ways to gather resources for a visual library they can access for current and future projects.

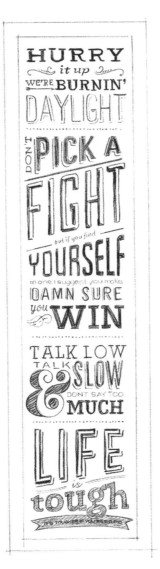
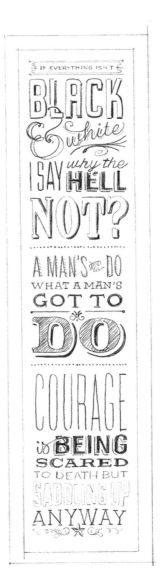

Sketches of a variety of signage fonts by Maggie Choate. Choate likes to combine sketching with digital elements in Adobe Illustrator. She scans her images and transposes them together until she gets the exact composition she is looking for. Her inspirations include colorful murals and signage around her hometown of Seattle.

A storyboard-style sketch by Anton Pulvirenti. As shown here, Pulvirenti usually skips the sketchbook completely and relies on loose A2 folio sheets. He prefers sketching from nature but also makes use of found images. Additionally, he has boxes of reference material printed from online sources and "tons of files of reference images" on his computer.

ESSENTIAL MATERIALS AND TOOLS

Attaining a genuine understanding of one's materials and techniques can be an enjoyable way to fully appreciate all the nuances of the art-making process. I don't know of any artist who doesn't love the accoutrements of their art. Whether it's a new color that's just arrived on art store shelves or a new tool they've discovered to make their process more efficient or unique, dedicated artists know the importance of using good materials and of practicing and refining methods to make their works the best they can be. Through fine-tuned design sensibilities, a flourish for presentation, and proficiency with their materials, chalkboard artists today have transformed the chalkboard from a standard educational tool to a canvas for innovative creativity.

SURFACES

Chalkboard artists have a variety of surfaces to consider for their works. There are several different types of chalkboards, including slate boards, porcelain boards, and magnetic boards. Magnetic chalkboards accept not only chalk but also chalk markers, which are used for permanent installations. Additionally, some artists make their own surfaces by applying chalkboard paint to a wall, a wood panel, or just about any surface that will accept paint. Easy to move, change, and store, a chalkboard panel is a good alternative to a traditional chalkboard.

The chalkboard artist's essential tools:

1 Dust-free chalkboard

2 White and colored chalk

3 Soft pastels

4 Pastel pencils

5 White and colored chalkboard markers in various sizes

6 Sponges

7 Rag

8 Felt erasers

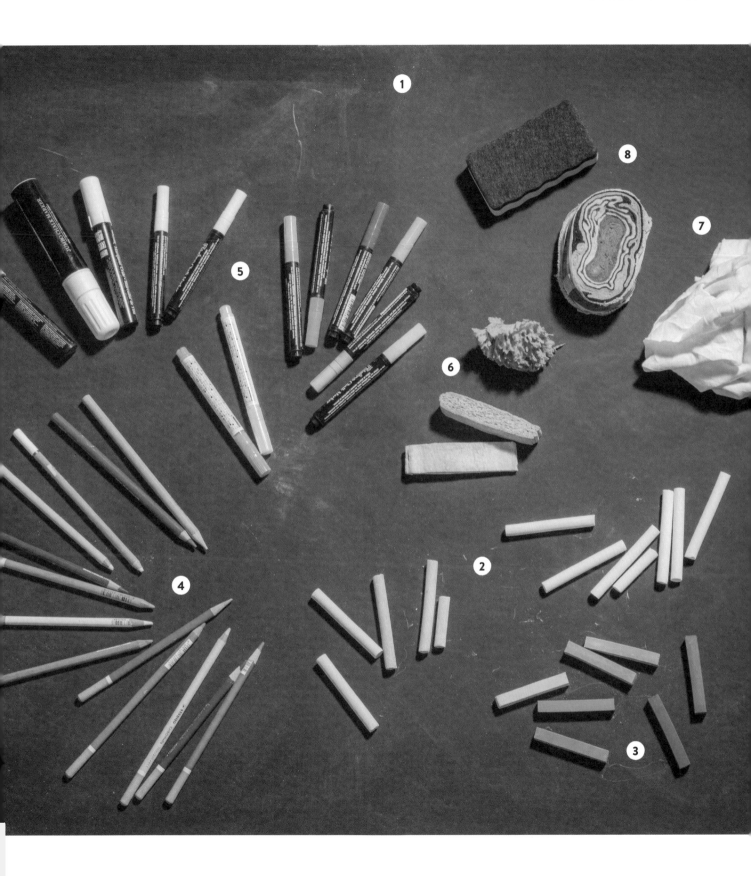

CHALKBOARDS: A BRIEF HISTORY

Chalkboards have apparently been with us for at least a thousand years. According to eleventh-century Persian scholar Al-Biruni's *Indica*, his history of India, slate writing boards were used in India at that time.

Blackboards were also reportedly used for music composition and education in sixteenth-century Europe. The term "black-Board" has been recorded in the *Oxford English Dictionary*, which provides a definition from 1739: "to write it with Chalk on a black-Board." The first documented evidence of the use of a chalkboard in the United States was in 1801, by George Baron, an English mathematician who was lecturing at West Point Military Academy. Educators from this period used a simple stick of calcium carbonate to mark the board. James Pillans, a Scottish teacher who is cited as an early adapter and another possible inventor of the slate classroom chalkboard, is also credited with creating the first colored chalkboard chalk in 1814, using a recipe of ground chalk, dyes, and porridge.

Over time, chalkboards began showing up as menu boards and signage in cafés, bistros, restaurants, markets, shops, apothecaries, laundries, and inns. They provided a convenient method of communicating the daily specials or bargains awaiting the prospective visitor. Sign painters' designs and scripts were increasingly employed until the chalkboard signs themselves became a little more artistic in presentation.

Over the last fifty years new chalkboard products have emerged, making way for more elaborate and expansive chalk creations that may have been difficult, if not impossible, to execute on a standard slate chalkboard. In the 1960s, the greenboard, a porcelain-coated steel plate, was introduced. Also produced in black, the green version was considered gentler on the eyes, made chalk residue less obvious, and was lighter and thus easier to transport, frame, and install than the standard slate chalkboard.

Chalkboards in Brendon Pringle's studio, ready for his next project.

As shown in various pieces by Maggie Choate, the chalkboard has become quite versatile, with a variety of sizes and formats to choose from.

A variety of formats, designs, and content regarding laundry services is demonstrated on these signboards by Brendon Pringle.

CHALK MEDIUMS

The tools that chalkboard artists use to make their designs include chalkboard chalk, soft pastels, and chalkboard markers, which deliver a paintlike medium. Painting techniques can also be used in conjunction with traditional chalk and soft pastels, by using sponges to apply color or dry brushwork for special effects (see page 44 for details).

White chalk is the number one item in a chalkboard artist's tool kit—lots of white chalk! But what sort of chalk to use?

Chalkboard chalk is pretty specific. It's usually smooth and compressed, with a hard quality to it. Made from calcium sulfate or gypsum, it differs from pastel chalk in its composition and processing. It's easy to find and easy to use. In addition to white, chalkboard chalk comes in a variety of colors, with the standard palette being limited to pastel pinks, blues, yellows, and greens. (**Dustless chalk** is a fairly good option for keeping chalk dust under control. It actually does produce some dust, but it's very minimal.)

You'll want a chalk that is quite dense and compressed for clean line work. **Compressed chalk**—a type of chalk similar to hard pastels—can be sharpened for detailed work. Chalk or pastel pencils, which can also be sharpened to a point, are essential for delicate line work. For more vibrant drawings, chalkboard artists can utilize **hard pastels**. They include less binder and more pigment, yielding a rich, vivid color application.

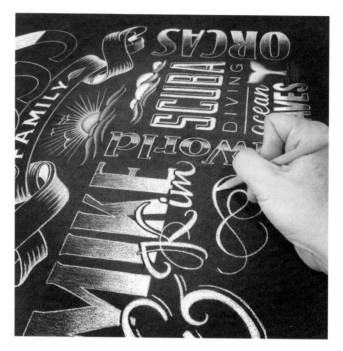

A stick of chalk can be worked with its point as well as with its side, to lay down broad, loose areas of color that can be built up in layers. For the tightest details, Maggie Choate gets a clean, crisp, and consistent line with a white chalk pencil. She recommends General's "Charcoal White," which delivers a bright, opaque line that helps make images pop.

There are some other tools that deviate a bit from the good old standard chalk and pastel. While most of the chalkboard artists featured in this book use chalk or pastels, some also use **chalk markers** from time to time. Although most artists love the dusty marks made by chalk on a board—it glides across the surface so fluidly and leaves a distinctive mark that it alone can deliver—in those instances when a more permanent solution is needed (for high-traffic areas, for example), chalk markers deliver a nice alternative to basic chalk. It goes down like a marker but dries with a semipermanent opacity that emulates chalk. It's easily removed with a paper towel and water yet stays put even with moderate wear and tear.

In addition to enhancing elements of their compositions with pastels, some chalkboard artists use dabs of **acrylic paint** for the brightest highlights.

ERASERS

Tools used for erasing chalkboard art include chalkboard erasers, artist erasers, damp sponges, hands, cotton swabs, and soft rags. Since chalk is so forgiving and a chalkboard surface is fairly easy to clean, artists don't need to worry about making or correcting mistakes. These tools can also be used to apply chalk and to remove chalk to deliberately expose the surface. See page 45 for more information.

A bold palette using pastels works wonderfully to highlight the details of a menu board composition by Takako Kurita. She adds touches of white acrylic paint to create a subtle sheen or small areas of highlighted light in her food illustrations. See page 44 for details.

IT'S ALL ABOUT THE LINE

With all the fascination for elaborate typography and detail, getting line work down to a fluid and smooth delivery is critical. Most artists will need to lay off the caffeine before attempting to draw decorative Victorian calligraphy for the first time! Pressure from the wrist and hand, position of the chalk, speed of movement—these all come into play when working to achieve a consistent and cohesive style and execution.

Whether working freehand, using a stencil, or following a detailed sketch that's been transferred to the board, practice makes perfect. Getting a feel for the chalk and how it moves across the chalkboard will help chalk artists learn just how to approach their work.

Another consideration is how various fonts work with each other to create the wonderfully well-composed yet random-looking combinations of lettering and imagery. Not only do the positive spaces need to work well together, but also spacing and the shapes of negative spaces should be considered for balance.

When creating chalkboard designs, practicing with elaborate fonts can really help you understand the variety of techniques available to help make your design exactly the way you envision it. Paying attention to things such as the type of chalk you use, the shape of the tip, whether using a chalk pencil or a standard stick of chalk, and the colors selected will hone your ability to make quick decisions about how to plan your designs on future works.

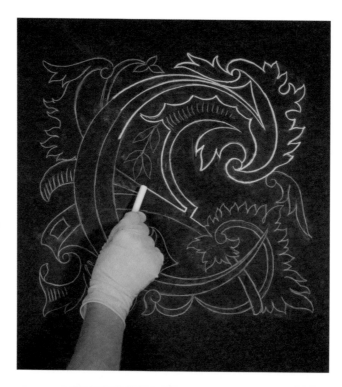

Step 1: Sketching and redrawing. The full-scale graphic image has first been sketched with soft chalk pencil, then redrawn with white chalk to define the outline.

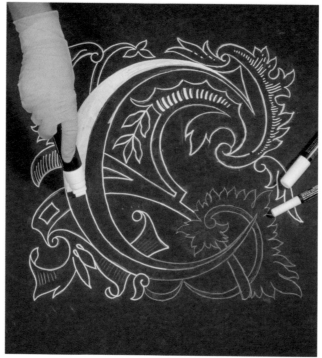

Step 2: Filling in. Chalkboard markers have been developed to provide a permanent way of making chalkboard-style art. Here the chiseled tip of a marker fills in broad, solid areas of white.

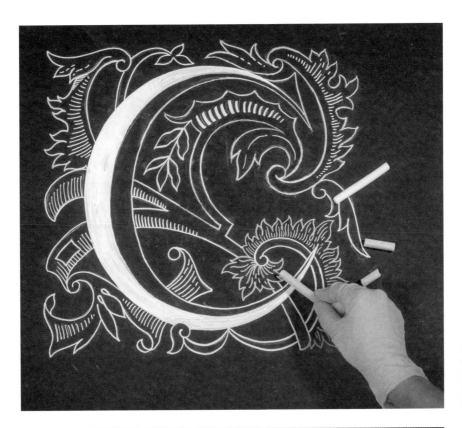

Step 3: Adding interest. Colored chalk is used to bring interest to one portion of the design, as shown here in pink and blue.

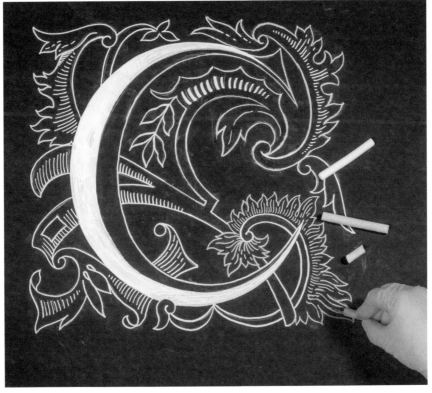

Step 4: Finishing. Detailing the design with blue chalk to finish the look.

OTHER TYPES OF LINE WORK

Other types of line work, including hatching and mark-making with straight lines, are crucial to achieving a refined design, with graphic treatment of shading and dimensional rendering being the norm. Hatching and layering are practical ways to get a lot of richness into chalk application. Whether leaving initial marks as is, blending some areas and then applying additional marks over them, or working in direct tonal ranges, the beauty of chalk lies in the variations an artist can obtain with layered texturing.

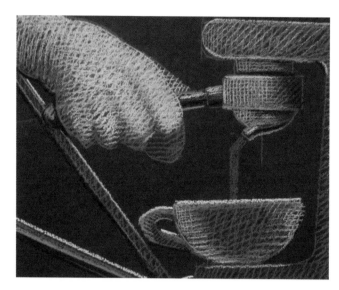

Anton Pulvirenti's hatching technique lends depth and dimension to the hand and cup shown in this detail.

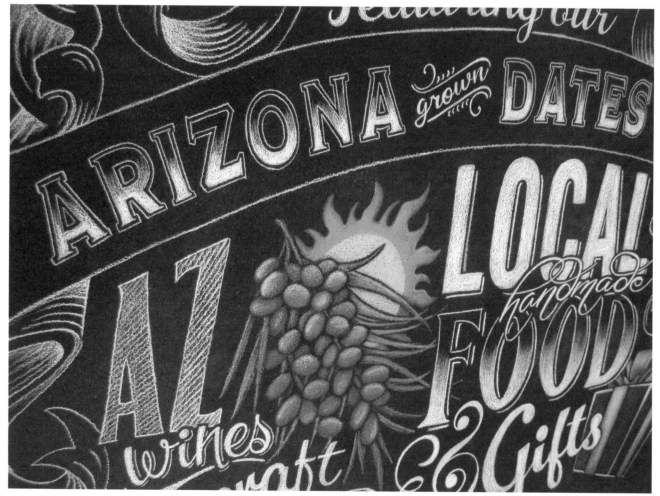

In this detail of Maggie Choate's *History of Beer*, a variety of shading techniques using a range of line weights can be seen.

Close-ups of Chris Yoon's designs demonstrate his skilled and subtle line work.

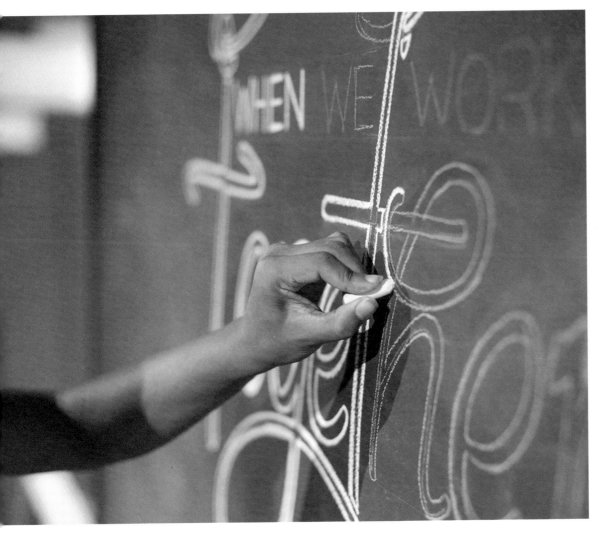

Dania Mallette (aka "The Chalk Chica") applies a heavier application of chalk over an initial layout. She says she likes to use shading and show the strokes/lines to give the lettering or design dimension. "Depending on what I'm drawing or the look I'm aiming for, sometimes I'll use my fingertip to gently swipe the chalk from the line I've created instead of using strokes, to give a more natural, blended look," she says. "Filling in spaces with all chalk without blending or shading oftentimes makes the design look 'muddled' and the lines get lost, which to me would defeat the whole purpose of the medium."

KICKING IT UP WITH COLOR

Chalkboard art may be thought of by the uninitiated as primarily limited to white marks on a blackboard, but the images shown throughout this chapter prove otherwise. As discussed on page 34, both chalks and pastels can be used to add vivid elements to designs.

The chalkboard palette is limited only by the materials at hand. Colors used should stand out from the black chalkboard background. Even dark earth tones should be legible and easy to read from a distance. Light values can read as very bright, so begin by using medium values, which should work very well as a base for creating colorful images.

As when rendering with any medium, attention to shadows and highlights can help artists achieve depth and detail. With a medium-value color as a base, you can go dark or light fairly easily with a building of color values. Stay in a narrow range of values for rendering and shadowing, while saving your bright lights for the final details.

Try using purple or blue for shadow tones rather than black so they stand out from the background. Or try creating a toned background around your images, leaving the black background of the chalkboard as the shadow color. Experimenting with positive and negative shapes and color will help you decide which approach works best.

Shading and rendering skills can be quite useful when working to create dimensional images on a chalkboard. Artists may use their fingertips, brushes, or felt erasers for blending and modeling different components of their drawings. It all depends on the stylistic look they are working to achieve. Since chalk likes to adhere to a slightly textured surface (referred to as the "tooth" of the surface), layering may be a little more challenging to achieve on a chalkboard because the surface is so smooth, so using methods that limit application to one layer is a good way to start. This means that selecting the right color and value on the first application is essential.

While Brendon Pringle's design could easily remain a two-color composition, the final, full-color work shows a very different—and vibrant—solution.

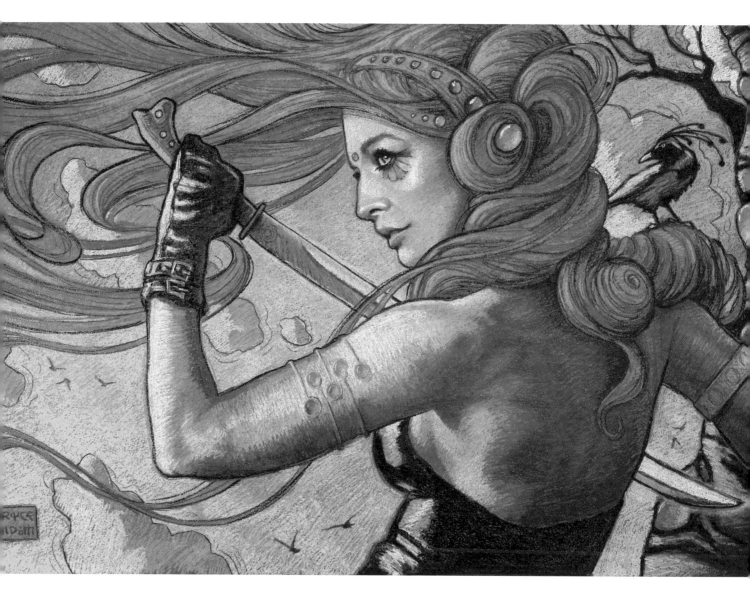

In this piece, Bryce Widom used a light yellow for the background, which helps the darker values of the figure pop.

CREATING AND ENHANCING DIMENSION

Illustrations with visual appeal are the key to a great menu board or sign. Ideally, their expert rendering will woo customers toward their choices. A skilled and experienced chalkboard artist will understand this psychological requirement and work to make their drawings irresistible. In the steps shown here, Takako Kurita demonstrates how she applies color and highlights to "cook up" yummy images.

BUILDING VALUES FOR DIMENSION

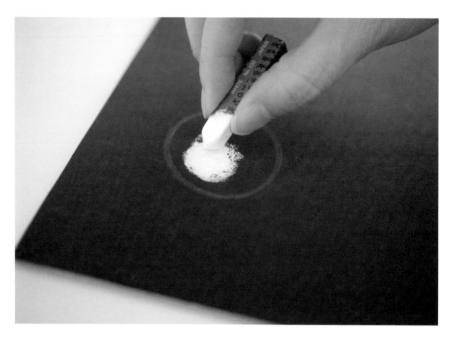

Step 1: Establishing highlights. Kurita begins with a white dot to establish the highlight area.

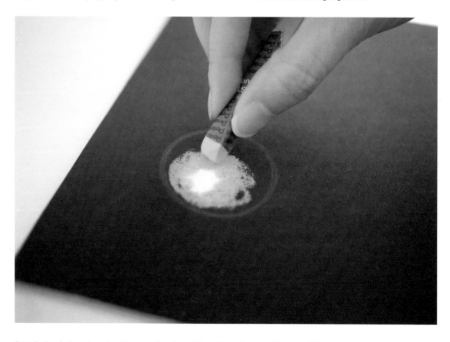

Step 2: Gradations in value. Surrounding the white with yellow creates a gradation in value.

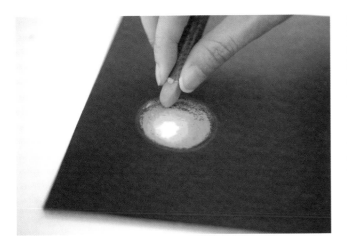

Step 3: Building the gradation. Applying a bright orange around the yellow continues to build the gradation.

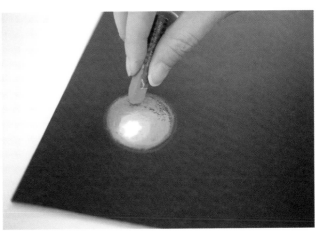

Step 4: Intensifying color. A bright red is applied over most of the orange and to outline the shape.

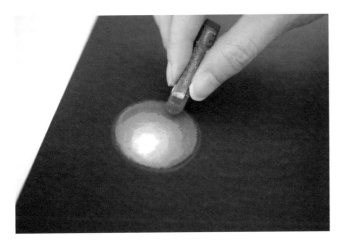

Step 5: Adding dimension. Adding a darker red shadow tone along the bottom of the shape gives the rounded form dimension.

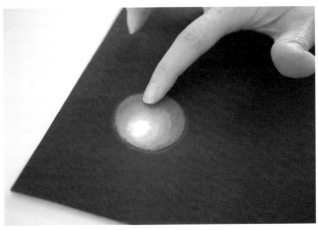

Step 6: Softening transitions. Blending with fingers softens the transitions between colors and values.

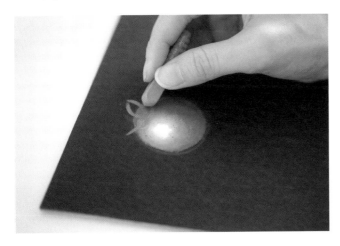

Step 7: Adding details. Tiny leaves are added at the stem end.

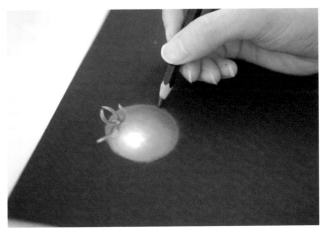

Step 8: Cleaning up edges. Using a black chalk pencil to clean up the edges.

STRENGTHENING HIGHLIGHTS WITH ACRYLIC PAINT

Here Takako Kurita uses a small sponge to apply tiny amounts of white CeramCoat, an acrylic paint, to enhance texture and add touches of light to her finished chalk drawings.

Step 1: Loading the sponge. Kurita loads the sponge with the proper amount of paint, picking up only a minimal amount along one of its edges.

Step 2: Light application. With delicate dabs, the sponge transfers just the right amount of texture to the drawing without disturbing the chalk layer underneath.

Step 3: Completed highlight. The final image, with the textured highlights applied.

REMOVAL TECHNIQUES

Leaving the darkest areas chalk-free so they read as negative space creates an interesting contrast with Bryce Widom's beautifully textured line work.

One of the cool things about chalkboard art is that you really can't make a mistake that will impact the overall final piece, if caught in time. Because chalk is so easy to clean up, you can easily remove any area that you don't feel happy with and simply redraw it.

Felt erasers, wet paper towels, or damp sponges will do the trick. A dampened cotton swab can be used to remove smaller areas, and paintbrushes can be very useful in tight areas, whether to make corrections or to intentionally remove marks to reveal the surface.

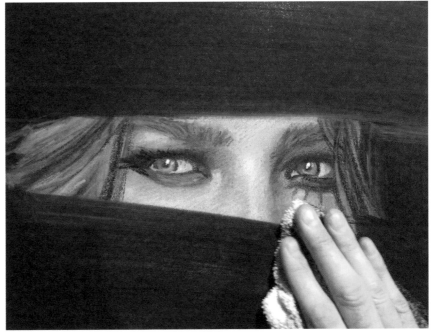

Bryce Widom uses either a damp cloth or a wet paper towel to remove large areas of a drawing, or to repurpose a board to make way for a new work.

DEVELOPING A COMPOSITION

To start the process of creating a large-format sign or chalk mural, a chalkboard artist usually begins with a sketch of some kind. As the sketching process evolves, a desired idea or ideas may come out of that for several designs.

The artist will take into consideration the location of the project, the size of the work, the duration that the piece needs to last, accessibility, lighting, audience, viewing space, and other site factors. Once this information is received, the designing process begins in earnest. Playing with the designing process is the fun part as options begin to formulate. From these options artists can narrow down the concepts into a final design that will suit their purposes.

Chris Yoon finds that drafting up a few tight sketches works for him rather than going through a large number of designs. "Because of my design background, I'm very much process-driven," Yoon notes. He creates guidelines for himself early on so he can move forward somewhat precisely with final sketches of design options.

Anton Pulvirenti can manage with thumbnail sketches drawn in less than a minute. This is a fast way to flow through basic concepts in search of one that works for the piece.

Not every artist will work from a sketch or previewed image. Brendon Pringle likes to work out his ideas on the actual board for the finished work. He may jot down scribbled ideas or notes but he prefers to problem solve on the spot. He says any sketch that shows up after this is mainly for others' benefit, so they can understand his intention.

Bryce Widom realizes his designs by accessing his subconscious mind. He does begin with rough thumbnail sketches

(literally the size of his thumb) but deliberately leaves the details out. This omission of information at the outset allows him to invent as he goes, following a very organic process of intuitive construction.

In addition to a particular preferred design approach, artists may have some backup for guidance—such as sketchbooks, notes, or computer programs—to assist with troubleshooting design challenges.

Another typical design process may include several line sketches that are placed into either Photoshop or Illustrator, then composed with various placements of the individual sketch components. A wide variety of options can be seen immediately, which helps the artist select the one that works best for any given assignment. Some artists prefer a rapid turnover of ideas, while others prefer a slower, more contemplative approach. It's all really very personal.

Although each of these methods of designing seems quite different, the constant is that all the artists access a well-honed knowledge of their craft and themselves, to formulate a work they feel is worthy of pursuit.

Nigel Eaton makes multiple versions of particular elements of a design, like key wording or images. "These diverse sketches are a useful way of narrowing down design options in consultation with a client," Eaton explains. He also finds visualization useful when contemplating the overall composition. "If I can divide the wall into shapes that my text and images will fit into in a balanced way, my work is half done." The florid script and design details of the finished work—signage at a wedding venue—fill the space nicely.

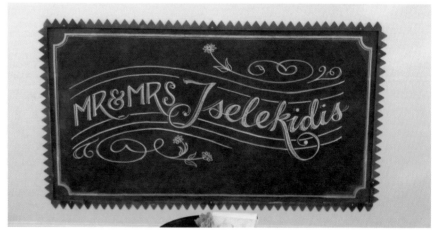

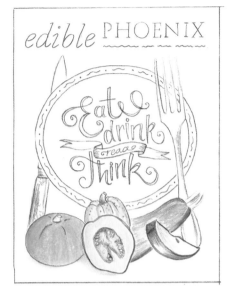
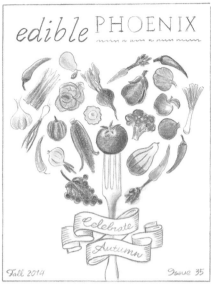
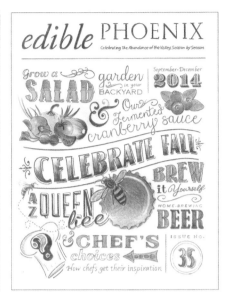

Three different exploratory sketches for the cover of *Edible Phoenix* magazine showing the preliminary placement of color elements, along with the finished design by Maggie Choate.

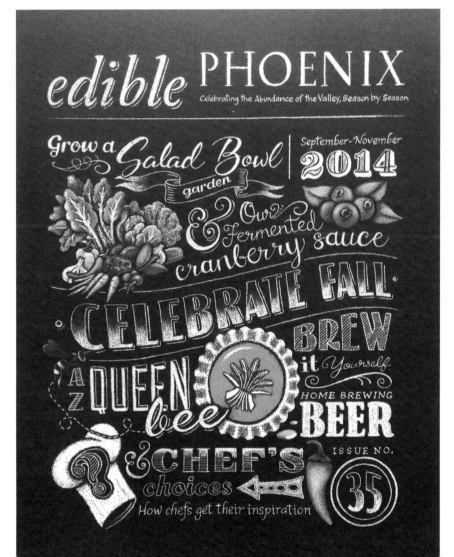

LOCATION, LOCATION, LOCATION!

In addition to developing good, strong choices for typography and imagery, it's equally vital to consider a chalkboard work's location and placement. The size and shape of the board, its placement, and how it relates to its setting must be addressed before the design process begins, especially in a public space such as a café or retail shop. Will it cover a wall from floor to ceiling, or is it a small framed piece? How will viewers interact with it? Will it be placed high, above viewers' heads? Will it be easy to read or see? What sort of light source is available for the work? Nigel Eaton sums it up succinctly: "The message I'm communicating needs to be clear and attractive in its particular place. It's no good doing an elaborate and finely detailed piece in a spot that can only be viewed from a distance."

Typically created on-site and in public, this ephemeral art form hinges on impermanence, just like street painting. Chalk is, after all, not very stable for longevity in a trafficked public space, so artists think about this when approaching these on-site chalkboards. If they need to switch mediums to a chalk marker for these situations, they will. Many enjoy the fact that the art is temporary in nature, and they welcome the opportunity to revisit the smeared chalkboard to arrive at an entirely new image. Of course, since these pieces are created mostly for a commercial market, their canvas's availability often relies on their patron's desires.

Curiously, many chalkboard artists expressed their enjoyment with the performance aspect of the work, a thread they share with street painters. Nigel Eaton says, "It feels like a performance, and I like that."

While most artists have no problem drawing in public, not everyone wants to work in the limelight. Dangerdust, an anonymous duo who has garnered attention with their beautifully executed motivational quotations placed randomly around the campus of Columbus College of Art and Design, creates their work offsite on an easy-to-transport chalkboard and easel so they can set it up quickly, without attracting attention.

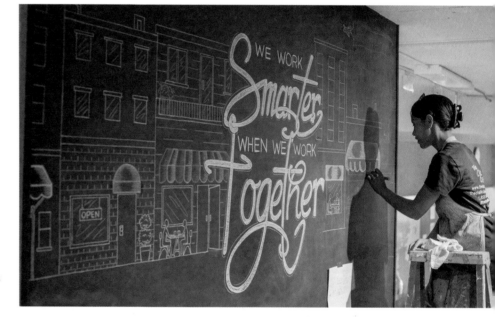

Dania Mallette cites a work's location as critical, as it informs how large her text must be for easy legibility. "I also take into account if it is going to be accessible to foot traffic and curious fingers," she says. "That alone usually determines whether I use regular drawing chalk or chalk markers."

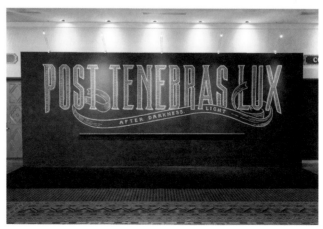

One of Chris Yoon's large-scale pieces at a trade show. He makes sure he schedules a site inspection prior to designing any of his chalkboard works, since cast shadows on the chalking area are often a concern.

TRANSFERRING DESIGNS

There are a variety of methods to use when transferring a sketch to the final chalkboard surface. Each has its pros and cons, so an artist must select the method that best suits a particular site and application.

CARTOONS

Cartoons are large, full-scale drawings of a design or sketch that can be placed on the final surface to see how it will look at full size. Creating cartoons on tracing paper is a great way to see various compositional options with the blackboard still visible through the paper. You can also layer several components, or draw the various elements on separate pieces of tracing paper, then move them around to see how different positions will impact the overall composition. Cartoon transfers can work well if your composition has loads of detail that requires accuracy. Cartoons can be transferred using several techniques:

Method 1: Slip white transfer paper behind the cartoon, and then retrace its lines to transfer it to the surface (in white).

Method 2: Apply colored chalk to the back of the cartoon, and then retrace its lines to transfer it to the surface.

Method 3: Perforate the lines of the sketch with a pounce machine or pounce wheel. This creates small holes that will allow a transfer substance (such as whiting powder or fine chalk powder applied with a pounce pad or fabric bag) to pass through the sketch to the surface. Simply rub or pat the perforated holes on the cartoon with the pounce pad or bag to transfer little dots of chalk onto the surface. To avoid ending up with just a lot of white dust on your surface, make sure the perforated holes are very small, and firmly rub the pounce pad over the perforations for an even application of chalk.

Dania Mallette uses a pocket level to make sure her lines are plumb. She avoids using transfer methods like projectors and stencils, preferring to approach her works freehand and rely primarily on her eye. Stepping back to see what she's completed is a big part of her working process. This way, she can gauge what's working and what isn't. She likes problem solving in the moment. She uses a chalk pencil to make the initial marks, wipes them with a dry cloth so that only a hint remains, then works directly on top of those light guidelines.

PROJECTORS

Projectors are another option for transferring images to a working surface. A projector can simplify the process and speed things up, since it allows you to play with scale and placement instantly. It's important to note that some projectors tend to distort images along the edges of the viewing frame, so be sure to check those areas for accuracy as you work.

GRIDS

Although they aren't used as often, grids are sometimes employed to transfer images. The grid is essentially a large map, scaled up to match the ratio of an artist's sketch grid. When following the placement of key lines on the sketch, it's easy to plot them on the larger grid at exactly the same place they fall on the smaller sketch. Chalk lines, rulers, and straightedges are standard tools that work well for creating grids on a variety of surfaces.

WORKING FREEHAND

If you have a flair for hand lettering or are very sensitive to the proportions of the various elements of your composition, you may feel very comfortable drawing your design freehand on your work surface. This approach takes a trained eye and a steady hand, along with an understanding of positive and negative shapes and a sensitivity to consistent scale.

OTHER TOOLS

Other items that can be used to transfer images include levels, drafting squares, triangles, and French curves—all old-school drafting tools that still hold their own with on-site work. Anton Pulvirenti suggests using an aluminum metal strip 8 x 1¼ inches (20 x 3 cm) for straight edges and curves.

As mentioned previously, the process of working with chalk is very forgiving. If you make a mistake you can easily clean it away and begin again, so you can try out all of these methods to see which best suits you and your particular project.

Nigel Eaton uses a projector to lay out one of his large-scale designs on-site.

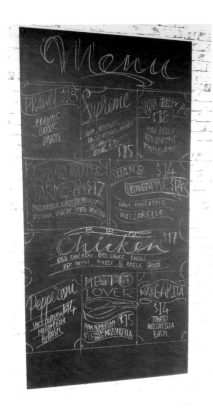

In the example above, Eaton roughs in his design with a freehand sketch. While some of these faint lines can be seen in the final work at right, the result is refined, bold, and perfected.

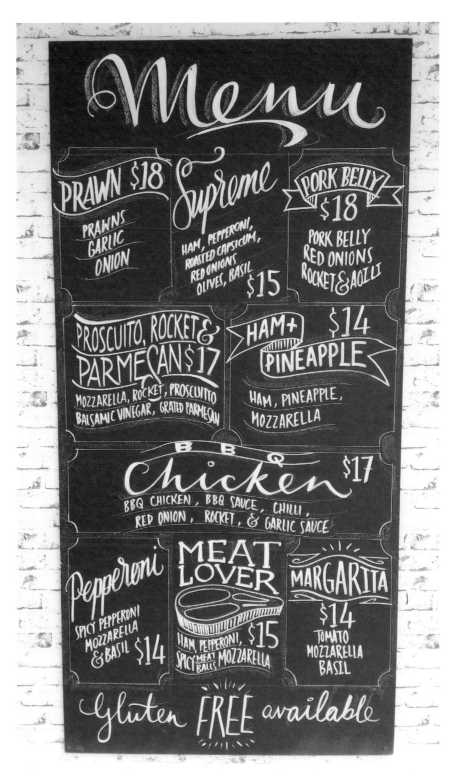

PRESENTATION AND PRESERVATION

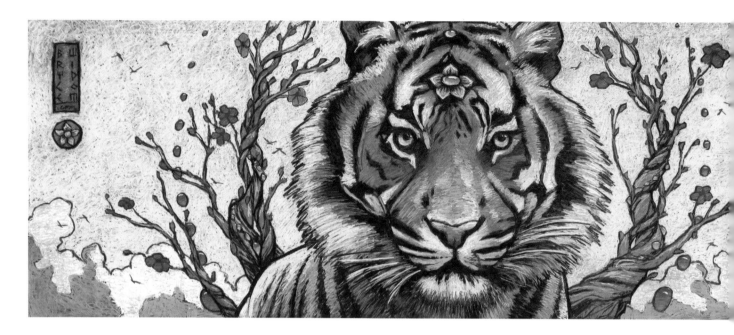

When all the work is done on a piece, it's ready to display to the public. Because these pieces are fragile, their life span may be limited to a day in some cases, particularly for menu boards or murals within close range of everyday traffic.

If you have the luxury of choosing its location, consider placing a work or installation in an area that will be somewhat removed from the public, perhaps high up, both to improve visibility and to be out of reach of curious fingers.

Display easels work great for smaller pieces because they can be placed just about anywhere. Additionally, a frame around the chalkboard can help delineate a boundary to keep people at a slight distance and help preserve the work.

If possible, apply proper lighting that washes over the image, which will help set it off as a focal point in the environment. For longer-lasting images, if required, chalkboard markers are a great way to go.

No fixative or preservative measures are taken, since the function of these temporary works is to communicate a specific message, usually for a short time.

Do the artists mind these issues? Not so much. The ephemeral quality of these works makes them that much more curious and appealing. Knowing that the art or design will not last means that you have an appreciation for it in the present. That beautiful script that embellishes the wall of your local retail shop may not be there next week, so enjoy it now. The blank chalkboard is a challenge, and the chalkboard artist knows just how to meet it.

Through the Valley, a large-scale chalkboard created by Bryce Widom for the Southern Sun Pub & Brewery in Boulder, Colorado, demonstrates a wide range of imaginative and evocative mark-making techniques.

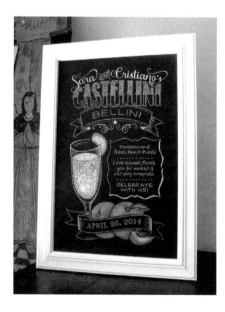

Maggie Choate's chalk handiwork—a custom sign inviting wedding guests to try the bride and groom's signature cocktail—as a framed tabletop piece.

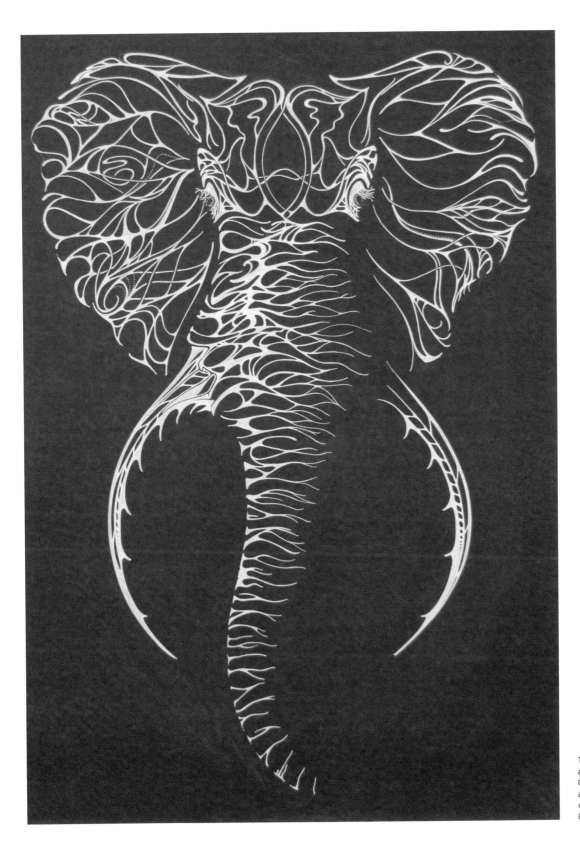

Taking a pattern-like approach, Catherine Owens's elephant by is a study in positive (line work) and negative (background) space.

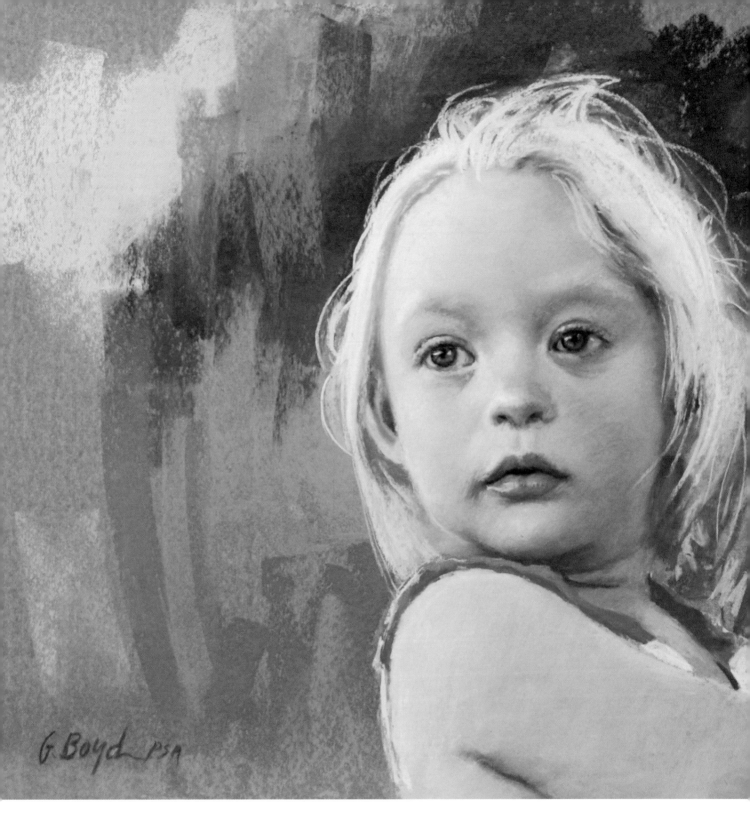

G.Boyd PSA

3 PASTEL FINE ART

With a heightened ability to see, the pastel artists find beauty and fascination in observing and then capturing the world around them. Whether a landscape, a still life, a figure, or a portrait, these artists dedicate hours, weeks, and months to exploring their subject matter in hopes of recording their understanding of these various subjects. Light, color, value, shape, and line all come into play as they pull out or build up dazzling images from a simple sheet of paper. Sensitive to nuances—a strand of hair here, a glint of light there—these masters extract those details and impressions from life that we mere mortals may not even be aware of. With care and dedication, each demonstrates their individual creative process-es, ultimately inviting us to view the world as seen through their well-trained eyes.

"I BELIEVE THERE IS A QUIET BEAUTY TO EVERYTHING AND THE LONG HOURS I TAKE TO RENDER MY PIECES OF ART AID ME IN FINDING A PART OF THAT TRANQUILITY."

—OTTO STÜRCKE

Gerald Boyd uses broad strokes of color to create an abstracted atmospheric back-ground, which sets off the detailed portrait in the foreground.

INSPIRED TO CREATE

When contemplating subject matter, artists look to a variety of sources and ways to access their creative impulses. For the group of contemporary realist pastel artists featured in this book, figures, portraits, nature, light, form, and playing with abstraction are all within the realm of inspiration. These artists must find the visual language that resonates with them most and commit to exploring that in order to communicate their thoughts, feelings, or impulses effectively.

Once inspiration has struck and the artist feels the need to begin a piece, how does he or she go about selecting the proper subject matter? The answer seems to involve a discovery process that guides toward a final decision. Observation and knowledge of good compositional practice come into play when deciding on suitable subject matter. Searching for that perfect setup, pose, expression, or point of view—these all come under consideration for artists who wish to make the most of their preliminary investigations.

Artists are of course inspired by those who came before them, and perhaps by specific periods of art history that particularly resonate with their own aesthetics. Otto Stürcke finds affinity with Old Master Flemish and Dutch painters for their use of tenebrism, or pronounced use of *chiaroscuro*, which means "light-dark" in Italian. Portraying an elegant balance focused on the use of light and dark is Stürcke's primary goal.

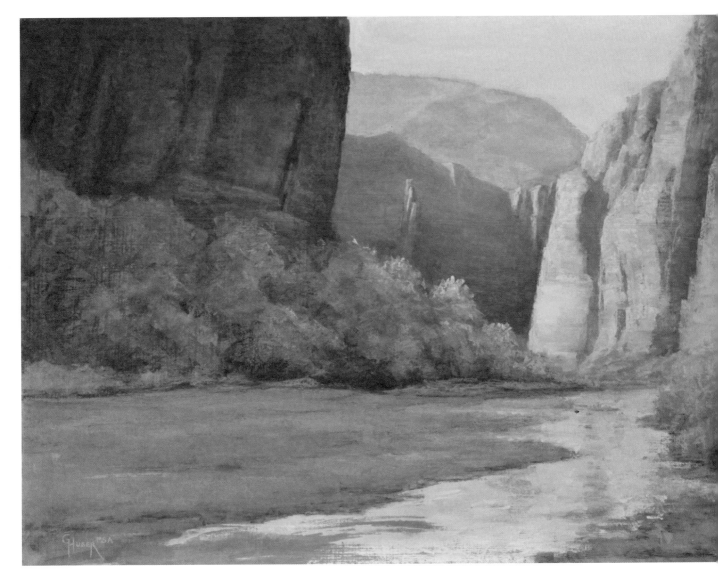

Gary Huber looks for that particular moment in his observations of the world around him to inspire him. Whether a spectacular sunset, a dramatic location, or something unique in his everyday routine, he looks for that distinctive visual discovery that demands his attention.

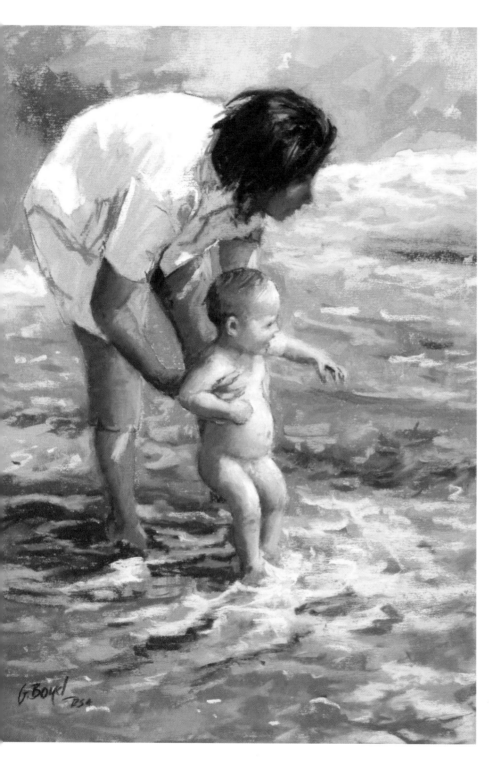

Appreciation for the beauty of nature propels Gerald Boyd into his explorations of various subjects, including landscapes, still lifes, and figurative portrait work. He finds fascination with the everyday lives of others, which he works to reveal through his drawings.

A TIME-HONORED MEDIUM

The history of pastel drawing can be traced back to fifteenth-century Europe. Thought to have first been used in France throughout the fifteenth century, the pastel medium was introduced to Leonardo da Vinci by French court artist Jean Perréal on his visit to Milan in 1499. Da Vinci then used the medium to create a portrait drawing of Isabelle d'Este, the Duchess of Mantua, that same year, working with black and red chalk and yellow pastel.

Often used as a medium for preparatory studies by those early adopters, it was not until the late seventeenth and early eighteenth centuries when artists such as Joseph Vivien, Jean-Baptiste Perronneau, Maurice Quentin de La Tour, and Rosalba Carriera, a female Venetian portrait artist, worked exclusively with pastels to create their images.

Waxing and waning in popularity throughout the eighteenth century, the pastel endured and was picked up again in earnest by nineteenth-century artists Eugene Delacroix, Jean-Francois Millet, Edouard Manet, and Edgar Degas, who is most popularly associated with the use of the medium. Americans Mary Cassatt and James McNeill Whistler contributed to spreading awareness and use of the medium in the United States in the nineteenth century.

Today pastel art is a widely accepted and respected art medium. While galleries and museums regularly showcase pastel artworks from both past and present, new genres around the use of chalk pastel have emerged in the last several decades as well, most prominently street painting and chalkboard art. With increased interest in the medium and the support of organizations like the International Association of

Pastel Societies, which is dedicated to the proliferation of the art form of pastel drawing, the use of pastel is here to stay, more vibrantly than ever.

Susan Lyon's tonal portrait glows with light through a masterful understanding of positive and negative space.

THINKING IN IMAGES

Like other artists, pastel artists seek and create visual reference for their artworks in a variety of ways. Thumbnail sketches, compositional studies, value studies, notes, and photography are all used by artists to keep track of and develop the steps to creating a successful work of art.

RESOURCING AND ORGANIZING PHOTOS

The photo library is one way to access image ideas or concepts for future reference. Many artists use photography to capture visual data and information, which is then logged into their files for easy access. Artists will often hire models to work from for their pieces; however, if an artist finds it impossible to work directly from life for extended periods of time for various reasons, the photography can save time in the working process.

Keeping your images organized is the key to keeping a successful image library. I make folders of various topics and organize them according to content and activity. Animals, people, places, objects, surfaces, textures, and so forth are all logged for easy future reference.

Gary Huber keeps thousands of photos of any one painting concept; he shoots at a location to find many different viewpoints and details. With a wealth of visual images to select from, Gary may find many suitable compositions for a number of future works. He keeps his images organized by year, location, date, and image number. He makes good use of these files as he accesses them to create numerous thumbnail sketches, which he annotates for a single work.

Susan Lyon finds plenty of inspiration in pursuit of her portrait work. She often photographs people during her travels, then stockpiles those photos for future reference.

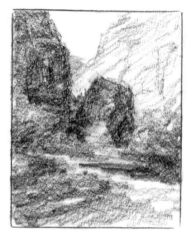

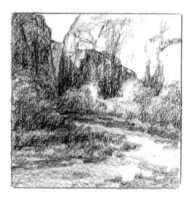

Ryan Bradley not only photographs all of his models, but he also then spends up to eighteen months working on computer-rendered compositions in preparation for a year's worth of painting. Bradley layers his photography with pattern designs on the computer and drafts complex compositions from which to build a body of work. Both elements seem to have equal weight in the organization of his compositions, which is most efficiently resolved by using computer software.

Gary Huber uses templates precut from four-ply matboard to standard frame proportions in vertical, horizontal, and square formats. He traces their outer dimensions in his sketchbook, then sketches within the shape. This process allows for quick and easy compositional variations that will work with his final drawing size, and helps him decide which format works best for the subject and the mood he wants to create. See page 84 for the completed work.

CHOOSING A COURSE

Every artist has a unique sensitivity to the genre or style of image he or she wishes to make. It could revolve around portraiture, figurative works, landscapes, still life, abstraction, symbolism, or even decorative patterning, but how to select the best composition? How to choose what exactly to draw?

Selecting the best image and composition for a piece is usually one of the most joyful and satisfying aspects to the creative process. Artists are looking for that particular subject that best represents what they wish to communicate about their world. Once they find the subject matter—say, a dynamic landscape or a softly lit figure—the artist will spend time observing and developing the particular composition he or she will pursue.

Some aspects to consider when choosing a subject include:

- Light effect
- Composition
- Content
- Viewpoint
- Scale
- Color
- Value
- Movement

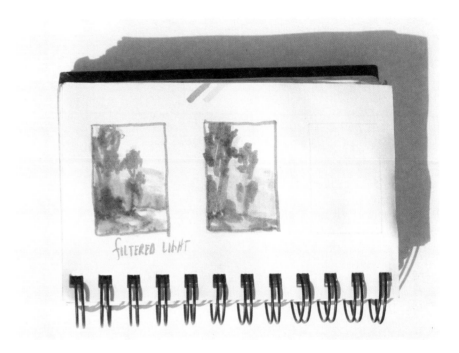

As an artist reviews these elements to determine which to emphasize, he or she may begin with one idea, yet end with something completely different. The step-by-step journey, which involves evaluation, consideration, and exploration, can provide all sorts of alternatives to an initial idea. For example, perhaps the figure painting becomes more about the space and light around the figure, or the landscape evolves into a study of subtle color variations. These kinds of discoveries all help expand one's imaginative vision.

Sketchbooks are a great way to capture and organize thoughts, quick images, notes, and more. Kim Lordier prefers to begin her working process with *notans* (a Japanese term that loosely translates as "black and white design"). Working with tonal markers, she intentionally compresses a landscape's values and shapes to quickly establish the essential dark and light areas within a composition. She may scale up a *notan* to her working surface, then proceeds to add color. She also refers to on-site photography to help further develop her intended composition. Between these two preliminary approaches, she finds a breadth of information to extract for her final piece.

DEVELOPING AND REFINING A COMPOSITION

Once an artist has an idea of what he or she wants to draw—having explored the subject matter and found compositional alternatives to develop—the process of documenting the subject matter with preliminary works begins, either through pencil or charcoal sketches, color studies, additional photographs, or even computer drafts.

Some artists like to manipulate or alter photographs to investigate compositional options. The process becomes less about the accuracy of a scene or live model and shifts to the photographic representation, which then becomes the subject matter for the composition. Composite images are also one benefit of using a photo library. Selecting images or components of images from a variety of sources can open one's imagination to create an image that simply doesn't exist in nature.

One way to assess a composition is to isolate it with the help of precut matboard "frames." By moving the frame over an image, an artist can quickly assess the various views available, as well as a horizontal or vertical layout, at the scale associated with the final working surface. If it looks good in the frame, it will probably look good on paper.

Using any of these options, either separately or in combination, each artist has a unique manner of accessing creative ideas that work with his or her own particular process.

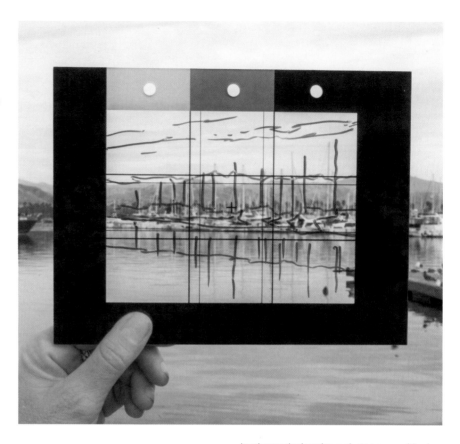

Another method used to evaluate a composition is through the use of a frame with a transparent film layer mounted inside. The transparent film layer would then have a grid marked out on it—either in vertical and horizontal orientation or with a diagonal X orientation—to handily show how a selected composition would scale up to the larger dimensions of a finished piece.

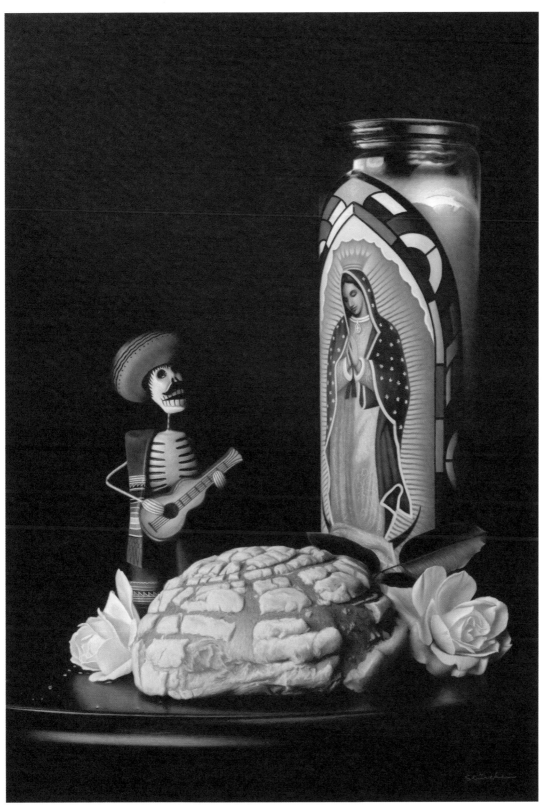

With its meticulous color placement and varying object heights, this composition by Otto Stürcke leads the viewer's eye around the entire painting. Stürcke prefers to work from life, so he spends a significant amount of time and energy on building his composition by carefully arranging the objects in his still life. The importance of finding a harmonious solution to the various elements he is drawing is key to telling a specific story—a connection with those items he is about to paint. Haphazard set-ups are not acceptable; Stürcke believes that the composition grabs the viewer's attention more than content and that good compositional design cannot be achieved with little thought. This stage of the process is very important to spend time on to make sure the composition is exactly correct for him.

ESSENTIAL TOOLS AND MATERIALS

The tools pastel artists use to create their works are really quite varied, a fact that's evident in their different painting styles. Some prefer soft, buttery pastels for gestural applications, while others prefer hard, sharpened pastels for detailed precision. From dry pastels to oil pastels, Nupastel hard pastels to pastel pencils, here is a short list of some of the tools suggested by some of our contributing artists.

PASTELS, PASTEL PENCILS, CHARCOAL, AND RELATED TOOLS

Pastels are sold in 3 grades—soft, medium and hard. Soft pastels are those referenced in this book, with medium and hard pastels being used for special effects.

- Soft Pastels: Art Spectrum, Caran d'Ache, Conté, Dakota Art Pastels, Dick Blick, Girault, Great American Art Works, Holbein, Koh-I-Noor Toison D'or, Mount Vision Pastels, PanPastels, Rembrandt, Richeson, Schmincke, Sennelier, Terry Ludwig, Townsend Terrages, Unison

- Pastel Pencils: Cretacolor, Faber-Castell Pitt, Caran d'Ache, CarbOthello, Derwent, General's

- Nupastels

- Vine charcoal

- Fine Art graphic soft lead pencils

- Sandpaper and other sharpeners

- Stumps and chamois cloth for blending

A selection of studio pastels.

- Erasers: I use melamine easy erasers for large canvas corrections

- Latex gloves and dust masks for use when handling pastels, to minimize exposure to potentially harmful pigments and prevent the inhalation of pastel dust

- String with counterweight for observing plumb lines

REPURPOSING BROKEN PASTELS AND PIECES

No one likes to throw their lovely pastel color bits away! Keep them and repurpose them by making them into usable larger sticks.

Simply crush the pieces in a mortar and pestle (street painter Alice Scott Crittenden recommends using a dedicated coffee grinder for this), add 1 or 2 teaspoons of distilled water, and mix together to achieve a thick paste or doughlike consistency. Form the mixture into a usable pastel shape. Place on paper towels or newsprint paper to dry, which usually takes two to three days.

A variety of pastel pencils and vine charcoal.

Terry Ludwig rectangular handmade pastels.

BRUSHES

To create the artworks shown in this book, artists used pastels along with a variety of bristle brushes, including sable, synthetic, camel hair, hog bristle, ox hair, pony hair, squirrel hair, in a range of sizes, as well as 1-inch (2.5 cm) foam brushes.

PAPERS, BOARDS, AND OTHER SURFACES

Choosing the right boards, papers, and surfaces is essential for achieving the best pastel effects. The most widely used pastel surface is paper with a slight grit or "tooth" to it. Pastels don't have a binder to help keep them on a surface. Special pastel papers with coated surfaces are specifically designed to assist in holding pastel. A surface with a coarse or dense tooth is able to hold multiple layers of pastel easily. Commercial pastel papers are easy to source in a variety of colors, and provide the right degree of tooth for pastel drawings. Wallis and Rives heavyweight sanded papers are recommended by several of the pastel artists featured in this book.

Because a working surface can be very specific to each image and artist, some artists like to make their own custom surfaces to create the exact finish desired.

Canvas and muslin can be used when glued to a board support, as these make suitable working surfaces for pastel. An easy way to make your own textured pastel panel is as follows:

1. Dilute some PVA glue with water for a thinned soluble solution and paint your canvas board surface with this.

2. While the glue solution is still wet, dust the surface with some carborundum powder using a sieve.

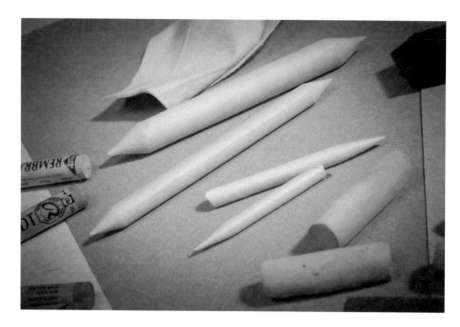

A variety of blending stumps are essential for working in detailed areas. Chamois cloths can be used for blending as well. The benefit of the chamois is that it does not deposit oil from fingers or hands onto the drawing. By placing the chamois over the tip of your finger, you can gently blend, soften, or remove the pastel as needed.

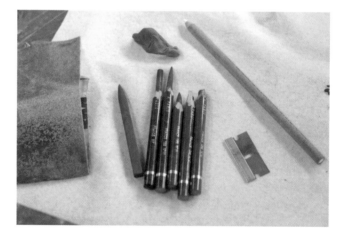

Examples of Susan Lyon's sharpened pencils ready for use.

3. Continue until you cover the entire surface.

4. When finished, tip the canvas board and gently tap the surplus powder from the board. Let dry.

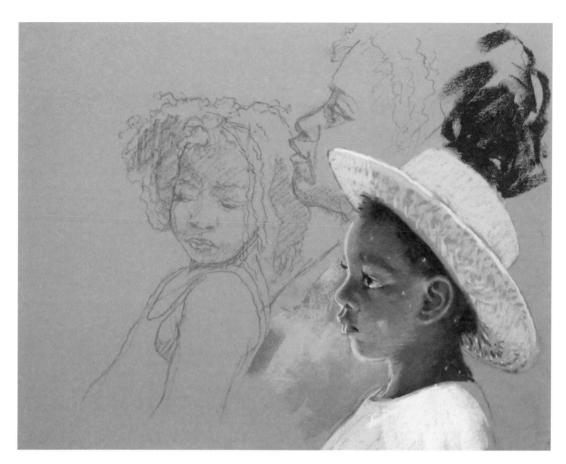

Gerald Boyd prefers to use a gray- or buff-toned paper for his works. The completed piece is shown on page 81.

Cuong Nguyen finds heavyweight Rives paper with a sanded surface an excellent choice for his fine detail work. The completed piece is shown on page 17.

Gary Huber's prepared panels, ready for use. Huber uses ⅛-inch (3 mm)-thick hardboard panels that are smooth on both sides. He cuts them into the various sizes needed and coats them with Gamblin brand PVA size, which makes the surface slightly tacky while also working as a sealant. Using a 2-inch (5 cm)-wide house paintbrush, he then applies two coats of acrylic gesso that contains very fine pumice powder and a small amount of water. He sometimes leaves the brush marks intact for additional texture as needed. To finish it all off, he tones this surface with a light scumble of a selected color pastel dissolved in a thin coat of odorless mineral spirits, which becomes the imprimatura, or base layer—a thin, transparent glaze of color used to stain the working surface or ground.

WORKING IN THE STUDIO

Once an artist has gathered and developed sufficient subject matter material through sketches, value studies, paintings, and so forth, he or she will often turn to the studio to continue the exploratory process to realize a finished work. While working "*en plein air*" or "*in situ*" is preferred by some artists (see page 71), most return to their studios to re-create working scenarios, after the day's light has faded or their model has retired for the day.

Organizing and accessing the preliminary work in a cohesive manner certainly assists in achieving productive results. Having your materials, sketches, and notes at your fingertips can be exactly what is called for in order to resolve any creative choices needed regarding color, value, contrast, hue, form, and so on.

Certainly the environment can be controlled and made comfortable, which may allow the artist to focus entirely on the task at hand. Artists who bring their work into the studio will definitely want to have an efficient, clean, and well-lit space to make sure their finished works best represent their artistic intentions.

EASEL AND STUDIO SETUP

The easel setup in studio is perhaps one of the most important aspects to creating an enjoyable and successful working environment. The easel should be set up at a comfortable height to the artists' eyes and hands, with the subject matter visually oriented at a similar height when viewing both at the same time. This type of setup aids in quick assessment of shapes, scale, and lighting, particularly when working from life.

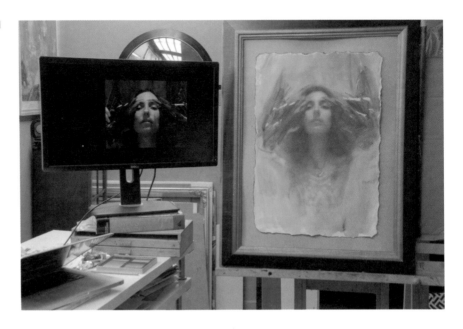

The artist must be close to his subject or reference image, yet have ample room to move freely for observational adjustments. Line of sight is extremely important, so keeping the area between the subject and the artist clear of clutter is key. Additionally, the area around or behind the artist should be clear of unnecessary clutter, as he or she may need to step back periodically to review progress. Perhaps several easels or workstations will be set up, with multiple works commencing at once.

Not surprisingly, many artists make good use of technology in their studio working processes. Not only are computers used to keep ideas organized, but digital technology in the form of iPads and handheld tablets, drawing tablets, projectors, and other technologies are also used widely in the studio environment. Some artists prefer a computer monitor close by for several reasons, typically for easy access to all reference materials and to

Susan Lyon sets up her studio with her computer monitor next to her drawing board so she has easy access to her reference materials, which include images she has manipulated in Photoshop. She likes using black-and-white versions, as well as "posterized" variations, studying them to prepare her compositional approach.

enhance detailed areas that might be difficult to see without magnification.

Ample light is always important—preferably north facing for consistency, but natural light can also be supplemented with one or more artificial light sources.

Ventilation should be considered, particularly when working with pastels, as pastel dust needs to be controlled for health concerns. Easels with incorporated vacuum systems can be purchased or made to extract excess pastel dust that falls while working. (See "Studio Safety," page 70.)

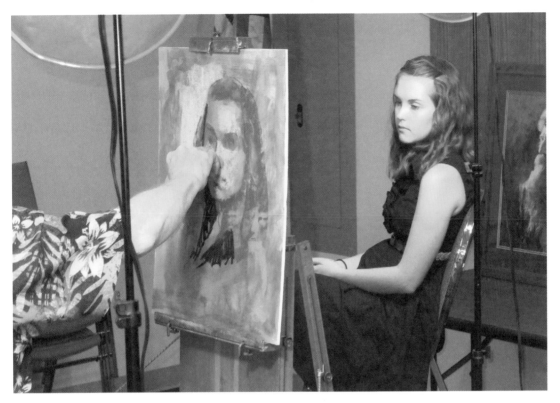

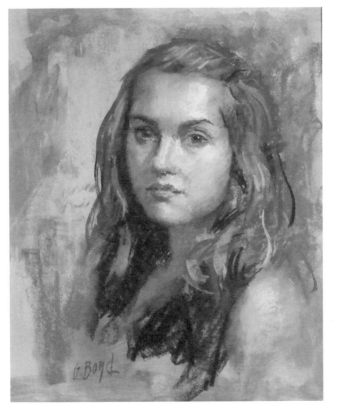

Gerald Boyd's studio setup, which he uses for his sittings with subjects to create his expressive portraits. He clamps a light source to the back of his easel in order to adequately illuminate his subject.

STUDIO SAFETY

As with all art supplies, it's important for artists to know the limitations and possible hazards of working with any medium they choose. Pastels are no different. Although pastels create a specific set of health safety concerns, there are practices that can be put in place to minimize the risks.

The biggest concern is breathing the extremely fine dust particles that result from using pastels. Keep in mind that pastels are made from pigments that may contain harmful contaminants to the upper respiratory system, so handling them with care is extremely important. Reducing the health risk in the studio is really about minimizing the amount of pastel particles floating in the air and clinging to surfaces or objects in your studio. It's advisable to keep your studio clean and well ventilated. Open windows and clean surfaces after a working session to eliminate the dust buildup. A HEPA (high-efficiency, particulate air) vacuum is recommended to capture fine pastel dust on surfaces. Avoid any blowing or fanning of the work, as this will only release more particles.

Vacuum easel systems are available to help keep pastel dust controlled during use, although they can be expensive. Respirators and dust masks are a suggestion, but unfortunately each type or brand may not fit securely on every face. Consult with your doctor about being fitted with an appropriate respirator and make sure you are trained properly in its use.

Use disposable gloves, a smock, and a head covering while working, and do not wear these items them outside your studio, as the particles can be carried to other locations on shoes and clothing. All clothes worn during the working session should be removed and washed immediately, and any residual dust should be removed from the skin.

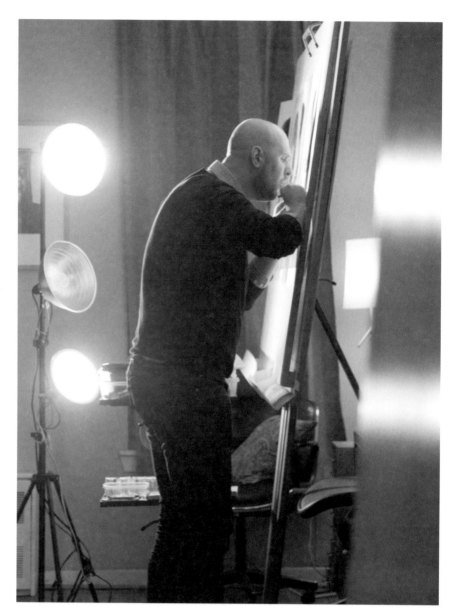

Following these simple guidelines can reduce the risks and help keep you working for many years to come.

Ryan Bradley's technical work requires ample lighting.

WORKING EN PLEIN AIR

While studio work is important, some artists prefer to work in a natural setting to capture those elements of their subject that are fleeting and elusive, particularly light. Working *en plein air*—French for "in the open air"—allows artists to reproduce the visual conditions before them while they work.

Working outdoors can be a real joy. The environment certainly can help an artist get into the appropriate mental space needed for tackling outdoor subject matter. Bringing what you need doesn't have to be tedious, since there are many options for streamlined easel/pastel box setups available. The portable kit for easy transport usually includes a pastel box easel (or a tripod with box supports, also called a pastel butler), a stool, an umbrella, and a carrying case. A backpack for miscellaneous items like value charts, viewing frames, pencils, tape, sketchbooks, and other incidentals completes the outdoor equipment list.

The creative process of making art outdoors, within nature, takes patience, skill, and practice to master. Capturing the changing light, colors, shapes, and atmosphere is a challenge for the artist who deliberates over the various choices that arise during this process. How are the details of a scene captured accurately, with all the fluctuations at play? The answer may be that an artist's decisions, selections, and observations are at the crux of this process, which reflects his or her individual sensitivity.

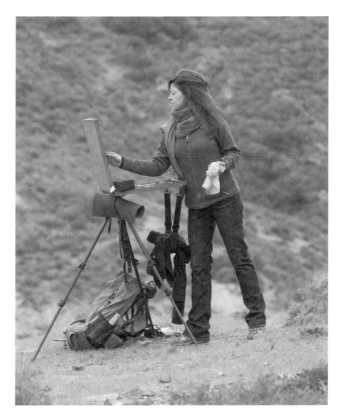

Kim Lordier's work revolves around landscapes, which she accesses directly by working outdoors or *en plein air*. Lordier explains that she is a reactionary painter, influenced by what is in front of her while she works. Her paintings reflect a knowledge and appreciation for nature and its nuances through direct observation. While not always successful in her reactionary explorations, Lordier finds that wonderful discoveries are also made in this manner.

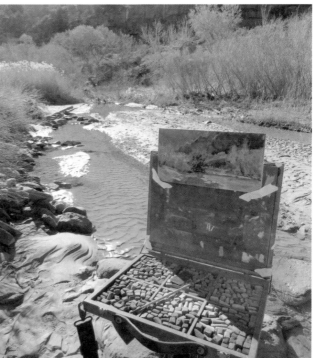

Lordier's portable *plein air* setup is a large pastel box that works as an easel. Add tripod legs and she can set it up just about anywhere.

ESSENTIAL PASTEL TECHNIQUES

The methods for approaching and executing a pastel work can differ dramatically from artist to artist. Palette, value, form, light, shadow, and scale are all contenders for the visual problems that need to be solved, and each artist applies his or her skills to tackling the task at hand. Yet how do these artists actually go about solving these problems? There are many different schools of thought regarding application, from impressionistic to meticulous.

Some begin with the simplest impression, mark, or line; it all depends on individual working method. Beyond that, the application of pastel can take many forms stylistically. From quick, gestural mark making to concentrated, uniform coverage; from broad, sweeping application to systematic, controlled building of layers—it all depends on the artist and, perhaps, the subject matter.

With each distinct creative approach comes various methods of achieving the desired effect. With all the pastel pencils and the range of pastel shapes and sizes available, the artist practices and plays to hone in on his or her own particular application methods. In any event, pastel technique is to be practiced, refined, and mastered.

SHARPENING PASTEL PENCILS AND CHARCOAL

To begin the working process on a final work, the first step is establishing the basic reference points for the composition. Using a piece of vine charcoal, a soft 2B lead pencil, a Nupastel, or a pastel pencil, an artist will first create the impression of the overall image. Using a finely sharpened pencil will give a very fine line, which, if applied lightly, can be worked over or erased as needed.

In order to keep lines very fine, sharpen vine charcoal on a sanding board. Gently move the charcoal back and forth on the sanding board until you get a nice sharp tip. Keep rotating the charcoal until either a blade or a point is created. Both are great for delicate line work.

When sharpening pastel or lead pencils, use a craft knife to take off all the excess wood, exposing ½ to 1 inch (1.3 to 2.5 cm) of open lead. Pass this lightly over the sanding board to achieve a sharp, delicate point.

BLENDING BASICS

Using the broad side of a pastel stick is a great way to simplify shapes with sweeping application. This can be left as is, blended with a finger, or manipulated with various solvents (such as alcohol or turpentine) and a foam brush to achieve an effective underpainting. Square pastels are great for this as they can be quite versatile with a number of mark-making options, from broad sides to thin edges and everything in between.

Using the tip of the finger to gently rub the pastel application will distribute the color into the paper surface, while unifying the color application. Some artists prefer not to use their fingertips as they often deposit oil onto the surface, affecting the texture and color of the pastel. If you do like blending, try a paper towel or tortillon (also known as a blending stump) to avoid this problem. The benefit of using a tortillon is that the artist can go into fine, focused detail areas that need manipulation without damaging other parts of the pastel application.

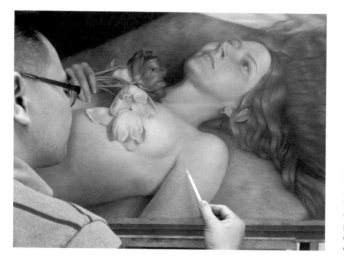

To create ultrafine details, Cuong Nguyen (left) uses a Nupastel hard pastel. Otto Stürcke (opposite) uses a sharpened pastel pencil. For areas that require fine or delicate rendering, especially those within highly detailed works, use pastel pencils, pastels, and Nupastels sharpened to a fine point.

VALUE AND COLOR SELECTION

What is value and why is it important? Value is a very basic property of color and refers to its lightness or darkness relative to black, white, and all the gray tones in between them. Where a color falls along that continuum identifies its value.

An artwork's value structure helps an artist create a unified composition that works throughout a piece. Pastel color selection can be manipulated and used much more freely if the correct value organization is observed. If an artist creates strong underlying value relationships in a work, then color can be played with endlessly, by using layers of broken color to achieve the correct value. Imagine the possibilities—for example, using reds instead of browns, and lavenders in place of sea greens!

Color selection involves several other considerations, including chroma, hue, local color, and temperature. Chroma is the intensity of a color. Hue is a color's simple name, for example, red, yellow, or blue. A shade is a hue that has been darkened from its original value, and a tint is a hue that has been lightened from its original value. Local color refers to the natural hue of the observed subject independent of any lighting conditions, for example, that the grass is green. Color temperature refers to how cool or warm a color may appear.

There are several easy customary ways to make sure your values are correct. One is to create a value scale on a cut-frame viewfinder to easily identify value matches on a gray scale. Just view your subject through the frame and look to see which gray scale color best matches it—that's your basic value.

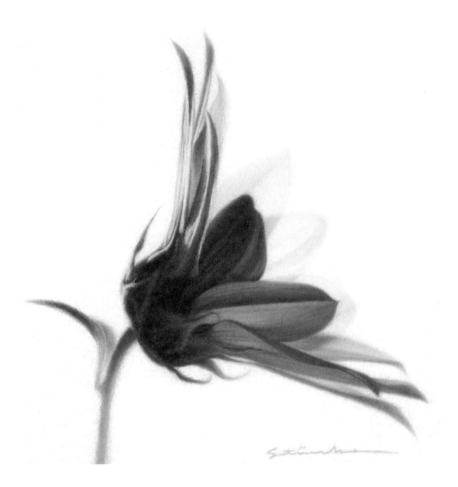

Otto Stürcke's tonal floral composition is a study in subtle values.

Another way is to hold a dark tinted mirror to the inside of your eye along the nose line, while reflecting the subject as seen with the opposite eye. This reverse view allows you to see an image with fresh eyes, and effectively shows when value assignment needs adjustment. The mirror simplifies the value scale into basic darks and lights, making shapes easily identifiable.

Yet another way to evaluate value organization, if you are working from a photo in studio, is to turn both your work and reference photo upside down periodically. This method allows an artist to see just how accurate the areas of value really are by eliminating the tendency to associate the subject as an object rather than a series of shapes.

Drawing with color or value is really a study in relationship, how one color plays off of another color—or rather, how the values appear next to each other. If the artist proceeds to make one correction in value with a midtone or dark tone, this may require adjustment of the light tones so that the relationship as seen in nature is rendered faithfully in the drawing. Every adjustment requires observation, to assess whether more adjustments need to be made accordingly.

A color wheel.

A value scale.

A value scale on a cut-frame viewfinder.

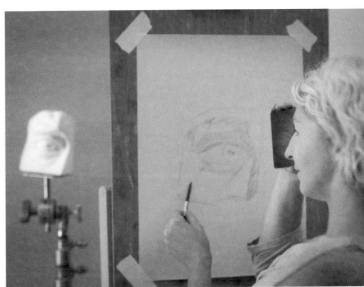

Using a mirror to assess value.

PORTRAIT IN PASTEL

Traditional pastel practice often involves creating the impression of a form or shape through the accurate representation of light and shadow. This is achieved by finding the correct color and value when studying a subject. Whether they are using a monochromatic palette or a full range of colors, artists must look for the darkest darks and lightest lights in order to understand how to construct their drawings. Once they have established the two ends of the value spectrum, artists may then work to capture the subtle range of values that define and reveal the forms within a still life, face, figure, or landscape.

Artist Susan Lyon begins with a focal point of her piece, in this case the eyes, and then develops the entire image by building on those first marks.

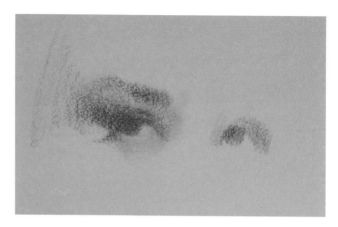

Step 1: Focal point. Lyon starts with the proper placement and scale of the eye.

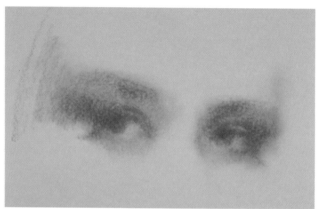

Step 2: Completing the eyes. Defining the shape of the eye and its nuances, she continues to work this area to almost full completion, and begins building out from there.

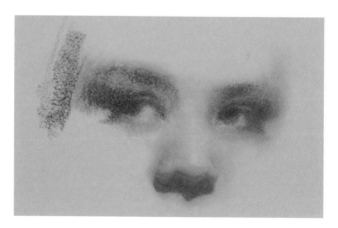

Step 3: Soft impressions. Additional elements of the portrait begin to take shape in a similar fashion, with soft edges and faint details.

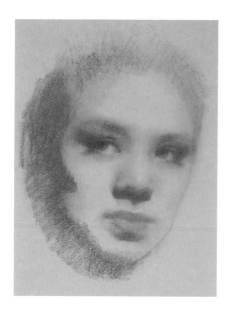

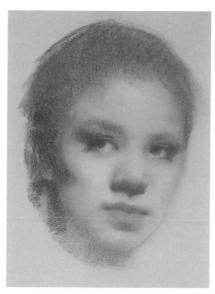

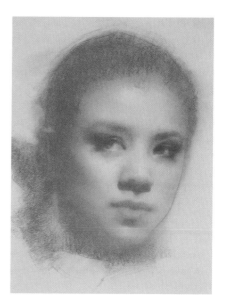

Step 4: Additional features. Very loose marks and chalk application establish the subject's hair on the left; delicate line work defines the right side of the face.

Step 5: Midtones. Additional midtone values are applied around the lips, nose, and eyes, unifying those elements and creating more depth among various structural areas in the drawing.

Step 6: Edges and values. Details are developed by refining edges and values.

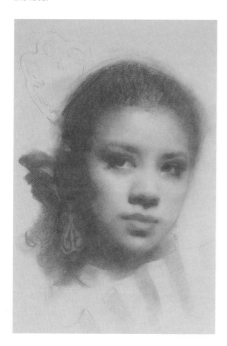

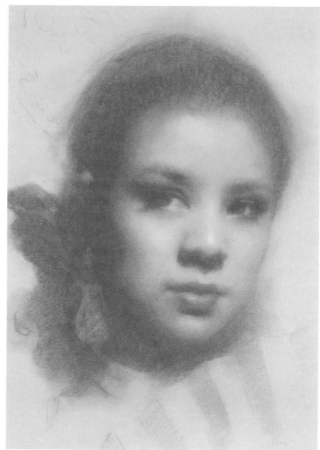

Young Dancer **by Susan Lyon.** As seen in the finished piece, highlights have been added with either a white pencil or by carefully erasing those areas of the drawing, and details refined throughout.

Step 7: Revisiting darks. Dark portions are revisited for additional interest. Tonal drawings require understanding about value relationships. For example, if one area is changed, then the corresponding or adjacent shadow would need to be reevaluated for accurate value assignment.

TIC

Cuong Nguyen's style of working involves layering colors, which build up to the desired shade or color he needs. Layering effects can be achieved with contour or hatching techniques. This requires a steady hand, with the artist layering color upon color for the desired tone. The beauty of this technique, when done effectively, is the transparent quality of colors showing through each layer in the final drawing. A rich finesse can be seen when artists use pastel pencils or finely sharpened pastels. Nguyen's working process manages to capture wonderfully detailed nuances and rich color variations in his portrait work.

Nguyen starts with a Nupastel to block out the background, then proceeds to soft pastels. He uses a variety of brands, citing in particular Unison and Rembrandt, whose soft, rich texture is perfect for his portraits.

Step 1: Envelope. Nguyen begins by drawing the image "envelope," the overall shape of the subject matter (in this case a portrait), and locates the shadow areas and plane changes.

Step 2: Underpainting. He starts dark and works light, using a brown umber for the shadows, proceeding to an earth-tone green to establish the underpainting foundation— an approach long used in classical portrait painting—before adding subsequent layers of color for the skin tones. His suggested skin tone palette colors are light yellow, yellow ochre, light pink, brown, green, and purple.

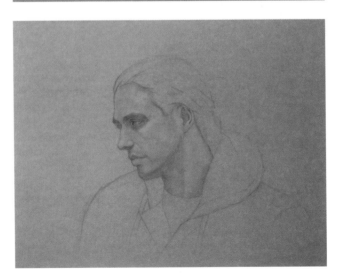

Step 3: Defining skin tones. Layering begins as Nguyen develops and refines his skin tone effect, next using yellows and yellow ochre.

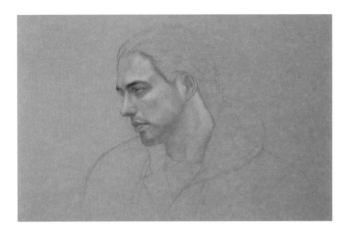

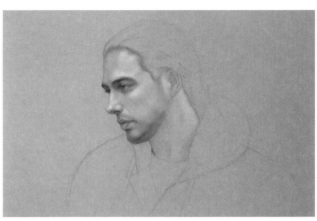

Step 4: Further refining skin tones. Nguyen next adds warm pinks and brown tones, while leaving the previous layers visible as needed.

Step 5: Skin details and highlights. With continued layering, Nguyen begins adding detail and highlights on the skin to create subtle shifts in color.

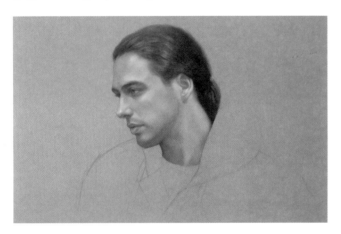

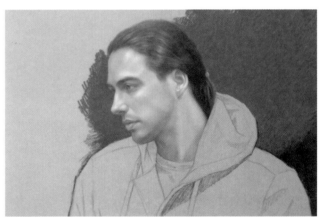

Step 6: Hair and warm areas of the skin. Extremities like the ears and the nose are made a bit warmer by adding pink to indicate the flow of blood to these areas. The hair is also added at this point.

Step 7: Background. The background is dropped in with a base layer of a cool dark gray.

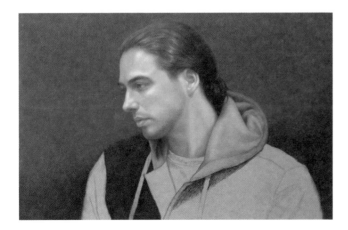

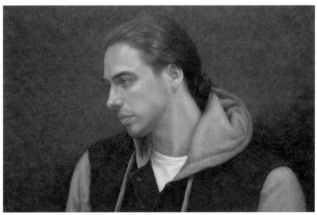

Step 8: Refining the background; starting the clothing. Additional layers are added to the background to create atmosphere, then the colors of the clothing are begun.

***Portrait of Sean* by Cuong Nguyen.** The clothing fully complete, the edges checked, and last-minute adjustments bring the piece to completion.

A GESTURAL APPROACH

Gerald Boyd's building of color involves gestural impressions of color and value, which are the foundation for the final piece. Establishing the base of his drawing with quick, sketchy marks, he uses these to add more layers, constantly evaluating the relationships between color and value, edging and shape. He begins with broad, rough application of color areas, breaking down the portraits into planes of color. The structure of the face is established through the use of various values.

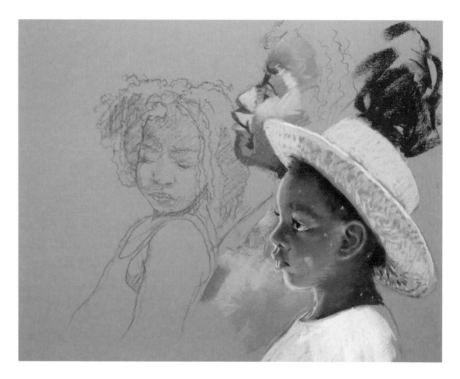

Step 1: Starting the first two portraits. With one portrait worked up, the second portrait is quickly established through loose application in its initial block-in stage.

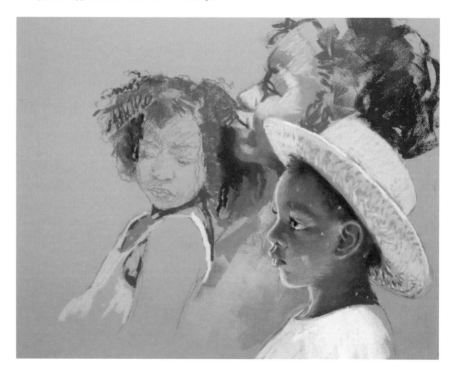

Step 2: Developing the third portrait. Boyd continues on to the third portrait, staying with loose application but specific color and value.

Step 3: Shadows, midtones, and highlights. Beginning to build up the structure of the second and third portraits, Boyd identifies shadows, midtones, and highlights to achieve this.

Step 4: Refining planes and shapes. Softening transitional edges of color, Boyd continues to refine the planes and shapes with more specific value additions, while still maintaining a loose, gestural approach.

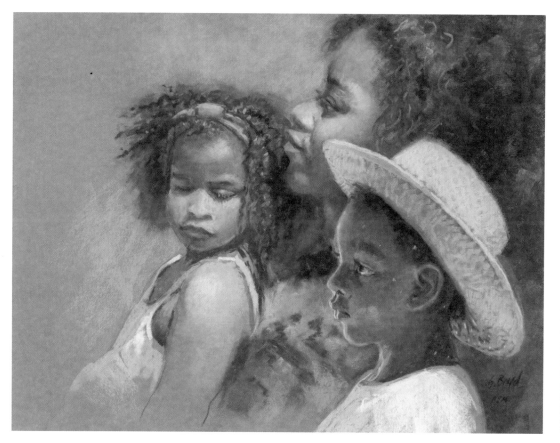

Family at the Black Rodeo **by Gerald Boyd.** Continuing this process, Boyd refines all aspects of the drawing based on the color and value relationships he has established. The finished piece is an impression of his subjects as opposed to an exact replication of them.

CAPTURING THE LIGHT

Impressionistic pastel applications may center on light as the key component in capturing the scene or model for the image. Breaking down a painting composition into a basic understanding of two components—light and dark—is a tried-and-true way to capture the essentials of your subject matter. Traditional atelier practices often teach students to squint while observing the subject, which helps the artist see the basic light patterns visible.

As seen in Gary Huber's process, by establishing the shadow shapes first, he is simultaneously creating the areas of light in the open spaces, which will be the focal point of his composition.

Once he has the basic light pattern established, Huber begins to block in middle values, here with a gray-purple, using the broad side of the pastel to define those middle value areas. He applies this lightly, to allow for layering of other colors over this as needed, then washes in the gray color, using rubbing alcohol and a 1-inch (2.5 cm) foam brush, to achieve a solid underpainting with the values consistent over their massed areas. Go light when manipulating pastel with alcohol; otherwise, you may wind up with a muddy mess. (See page 86 for more information.) Huber suggests laying the painting flat so the alcohol is easily managed.

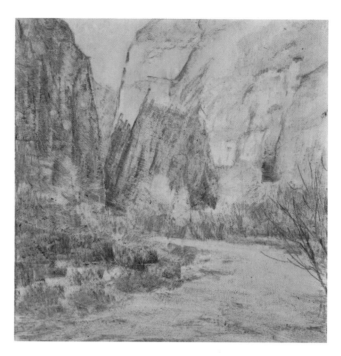

Step 1: Starting sketch. Huber first sketches with a soft graphite pencil, a Cretacolor Fine Art Graphite 2B pencil. Using the side of the lead, he proceeds to block in areas of darker value. He only adds details at this stage if he needs to remind himself of something he feels is important later on in the drawing process. Huber suggests using the broad sides of the pastel for the first several steps in developing an image. Only near the end of the work does he add details using the sharp edges and corners of the pastel.

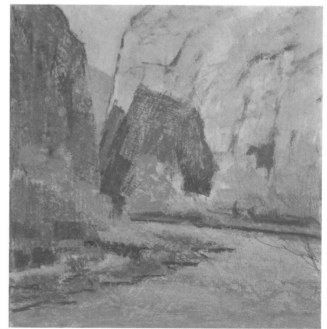

Step 2: Defining major masses; blocking in middle values. Huber next uses a medium or large willow charcoal stick to draw his image on his prepared surface, making sure to get the major mass edges defined before blocking in these areas with the broad side of the charcoal sticks. He likes using the charcoal in various densities to establish his initial value pattern. Using a finger he smudges the charcoal as needed to make it lighter or darker. This helps with pushing the charcoal into the low spots of the gritty support he works on. When approaching the light areas of his composition, he simply leaves these open, allowing the color of his working surface, in this case the golden color, to act as a light color.

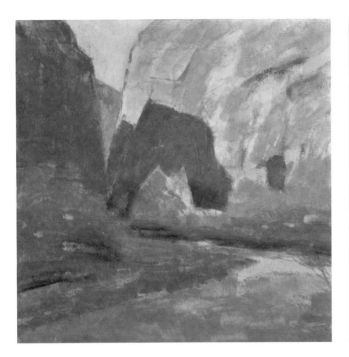

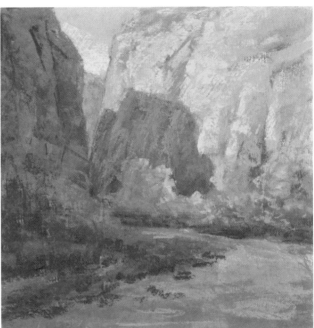

Step 3: Resolving value changes. Still working in a basic palette established to resolve value changes, Huber goes further into the drawing to bring the darks to their proper level and adjust any lights that correspond to the adjustment. When he picks up a pastel he'll use it all over the piece, wherever it may go, to keep the drawing unified. Here he uses a Terry Ludwig V100 (Eggplant) pastel for his darkest areas, which provides a very dark purple color that works as a satisfying near-black. This color works well under almost any other dark color.

Step 4: Adding local color. After his value work is complete, Huber then moves on to local color—the color of the objects as seen by the eye—for example, a blue sky, green trees, red rocks, and so on.

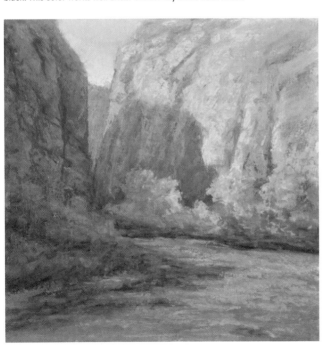

Step 5: Refining the lights, darks, and highlights. At this stage he continues to adjust his work and add more detail to move toward completion. Since Huber works from dark to light, he leaves the highlights for the very end of his process. While shadows typically remain less refined, the areas with light will demand more attention, as this is what the eye focuses on, so shadows remain an impression rather than a focal point. Edges are examined for sharpness or softness, light is considered in terms of proper color assignment, and details are fine-tuned or dismissed, depending on what the artist feels is important to the work.

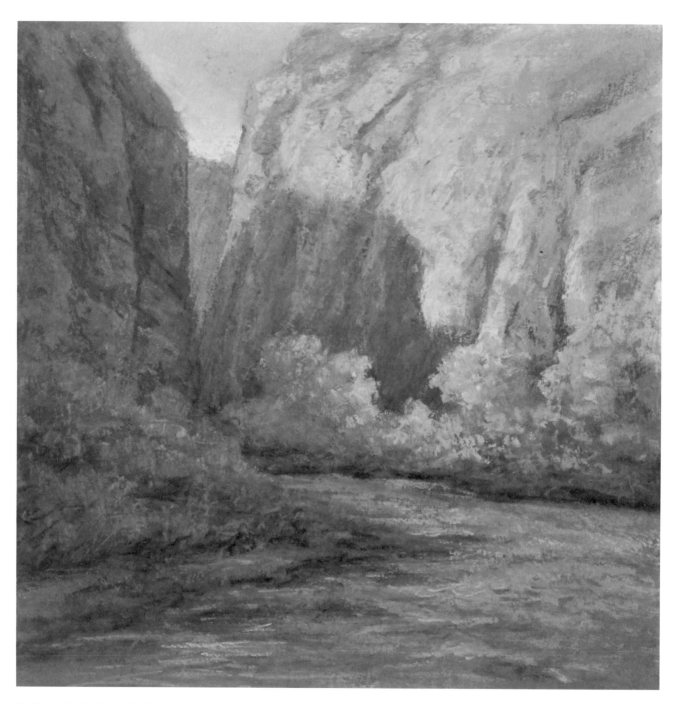

Zion Shadows **by Gary Huber.** The finished piece includes Huber's final refinement of details and of areas of light and dark within larger value sections.

INDIVIDUALIZED AESTHETICS

Artist Ryan Bradley does not describe himself as a pastel artist, but rather as an artist who uses pastels. His process requires using the appropriate medium to suit his conceptual needs; in this case, it's pastels.

Bradley's approach has everything to do with exploring a conceptual curiosity around a condition known as *pareidolia*, a psychological condition that allows us to recognize a face with minimal information from a stimulus—think "man in the moon" or seeing faces in clouds. Artists tap into pareidolia quite often, seeing landscapes, animals, and other recognizable imagery in otherwise randomly patterned surfaces.

In order to explore this concept in his work, Bradley makes his drawings quite complex visually, layering patterns and representational images as needed. In order to leave some interpretation of his work for the viewer, he employs a construct he calls *subtractionism*. This means that he emphasizes certain specific features, while subtracting others.

After transferring his design image to the paper, Bradley will place stencil media over it, selectively determining which portions of the stencil to remove. He then begins to draw on top of this using a pointillism technique. After he is complete with the drawing, the stencil is removed, losing significant portions of his finished drawing. What's left is the image we see, with part of the image subtracted from the paper. It is certainly a meticulous and laborious process, but Bradley enjoys the "hand at play" aspect to his drawing and stencil cutting.

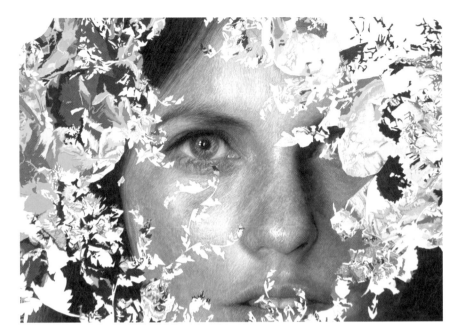

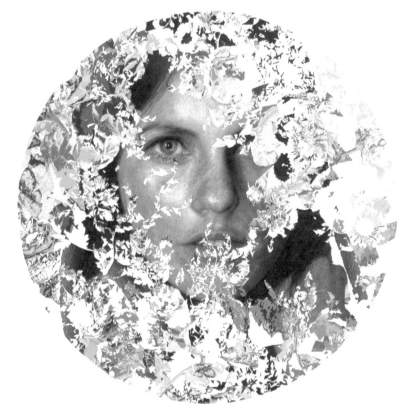

Bradley's work exhibits a distinctive aesthetic approach, one that yields very interesting results. He advises patience when working out a unique individualized process—perseverance is key to finding success.

PAINTING WITH PASTELS

Although pastels are a dry medium, they can also be manipulated quite effectively to achieve the quality of a wet medium, like oil paint or watercolor. Artists use a variety of solvents or thinners to move the pastel color around on their surfaces, creating a thin and versatile underpainting for a base. Layers of chalk can then be built up on the surface easily, without picking up the base layer, avoiding a muddy mess that can happen with excessively heavy chalk applications.

Here I demonstrate a step-by-step process for using wet mediums to create an underpainting.

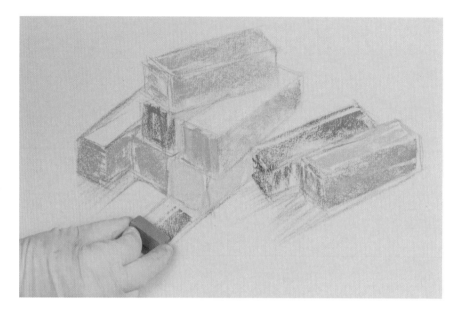

Step 1: Blocking in basic colors for the underpainting.

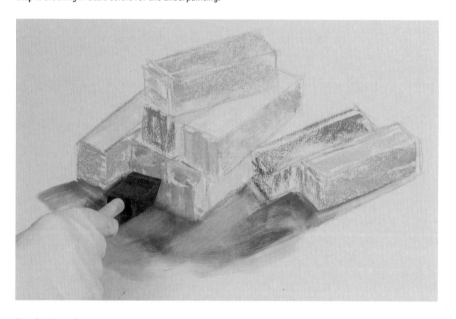

Step 2: Using a foam brush to apply a thin layer of alcohol or turpentine over each area of applied color.

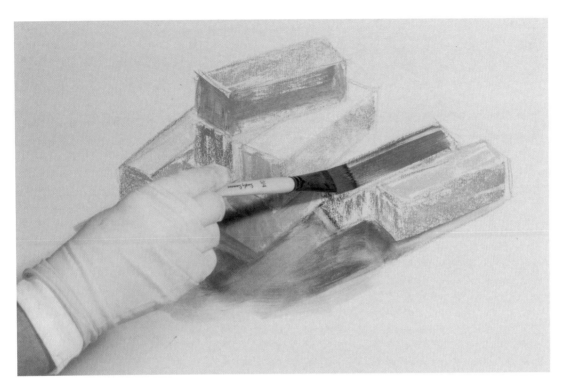

Step 3: Using a bristle brush to work the alcohol or turpentine into the underlying color.

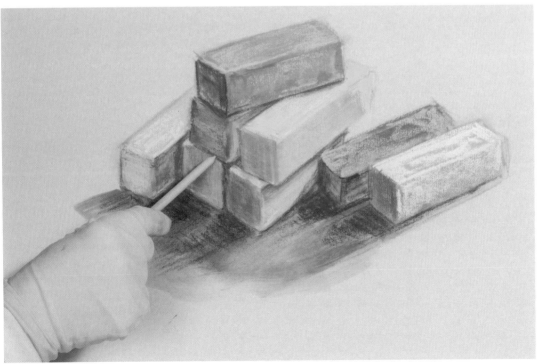

Step 4: Working in details with a stump after adding subsequent layers of pastel.

LANDSCAPE IN WET PASTELS

Gerald Boyd also uses a bristle brush dipped into rubbing alcohol to transform his base layer of pastel into a workable underpainting. The alcohol liquefies the pastel, which can then be manipulated in a painterly fashion. The alcohol is fast drying, so continual working is unaffected. The resulting effect is that of a loose water-color, which is now ready to accept more defined detailing.

Step 1: Applying a base layer. Boyd applies a base layer of pastels over an initial drawing of the scene.

Step 2: Creating an underpainting. He then uses a brush to work rubbing alcohol into the pastel, moving it around to create an underpainting.

Step 3: Applying an additional layer of pastel. Boyd works directly on the under-painting, adding more pastel to achieve the final result.

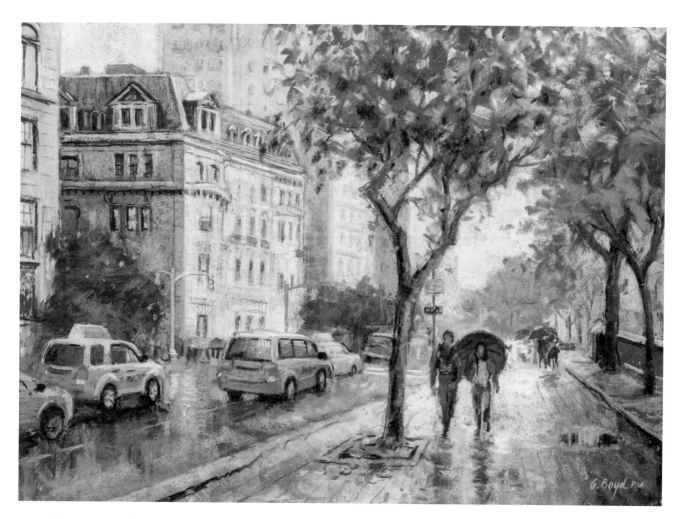

Along Fifth Avenue **by Gerald Boyd.**

WET PASTELS: OTHER GENRES

Kim Lordier uses a Nupastel to create her initial light sketch onto her sanded pastel paper. She prefers Nupastels in several colors, using a middle-value blue-violet color (#244) for her underpainting. She then uses a darker indigo blue value (#285) to establish her darkest darks. To finalize the underpainting she may use Turpenoid with the pastel for a more transparent effect. With the basic sketch completed in a mid-value blue/violet over an ochre-toned imprimatura, Lordier uses Turpenoid to set this color as her structural underpainting. (See page 15 for the finished painting.)

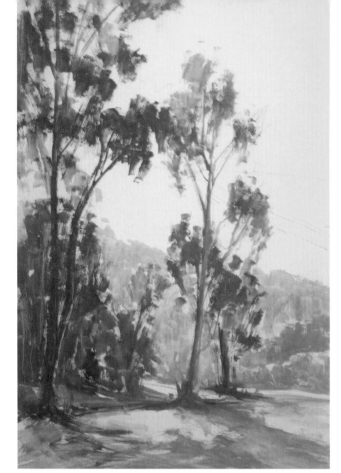

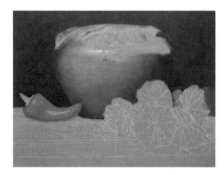

Otto Stürcke uses hard pastel pencils to rough in his initial sketch, then dilutes the marks with turpentine, rubbing alcohol, or mineral spirits. This is used as a way of achieving tonal washes that fill in the tooth of the paper, which provides a smoother surface to work on for fine detail.

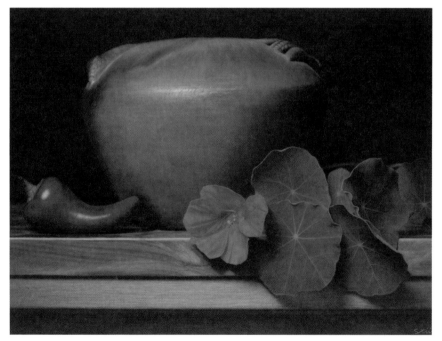

FIXING AND FRAMING PASTEL ARTWORK

Some artists steer clear of fixative, but others disagree. It all depends on your process. Spray fixatives tend to alter the finish and color of pastel drawings, but they can be effective if further alterations are desired in the future. An example of successful use of fixative is that of Edgar Degas, who late in his career developed a process involving the application of numerous layers of various pure colors on top of one another, with each layer stabilized by a fixative consisting of a diluted shellac solution. Through this method he was able to successfully use tracing paper fixed to a card as an effective medium for pastel, brilliantly achieving his unique textural finishes.

When an artwork is complete and ready to exhibit, there are a few things to consider concerning preservation. Framing a pastel behind glass is by far the best way to preserve a finished work for longevity. Moisture, humidity, wind, oil from hands and fingers, and other irritants will accelerate the decomposition of the work, so keeping it as clean and free from outside influences as possible is important.

Some tips for framing pastels:

1. Use a UV-filtering glass, not Plexiglas or acrylic sheeting, as they attract dust with static electricity.

2. Avoid touching the surface of the pastel drawing when framing.

3. Use a frame molding to support the layers of materials needed for the framing.

4. When selecting a mat, use acid-free with a reverse bevel cut. This prevents the pastel dust from being visible on the bevel edges. Using acid-free foamboard spacers is an optional way to create space where pastel dust can fall.

5. Use an acid-free backing board to mount the original work.

6. Use a dust cover over the backing board to keep out insects and dust.

7. Do not attach anything to the frame that requires hammering, as the vibration will shake loose some of the pastel dust.

8. Keep the work flat on its back to preserve the chalk dust when traveling.

When considering a location for hanging the work, remember that strong or consistent light can be damaging to pigments. Over time the colors may fade, so keeping a pastel out of direct sunlight is a very wise idea.

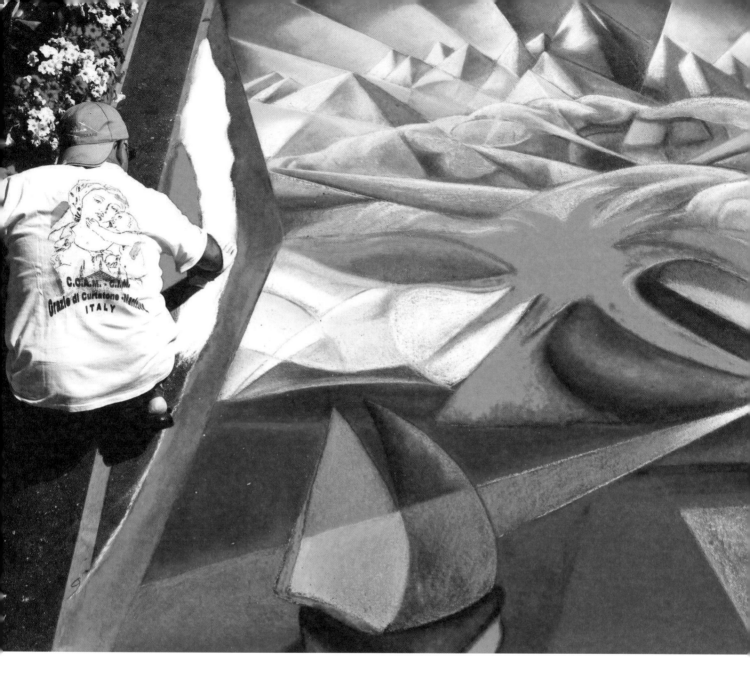

4 STREET PAINTING

Street painters need an audience for their work. Performers with a desire to expose their individual creative processes, street painters call urban pavement landscapes their canvas, drawing up elaborate and jaw dropping images that can baffle the mind and delight the senses. Through this public performance, the artist's creative identity is revealed with each painting, giving us a glimpse into the hearts and minds of these unorthodox creators.

The unlikely marriage of a material so temporal as chalk with the well-trafficked sidewalk defies logic—certainly the image won't last long and may be washed away at any moment? The street painter laughs at this notion, for impermanence is something he or she learns to embrace. Not to be deterred, the street painter, armed only with chalk pastels, works to change the mundane to the extraordinary, one pavement at a time.

A detail of an abstract landscape by Bruno Fabriani.

"PEOPLE WANT TO SEE THE EXECUTION, FROM THE SKETCH TO THE GRID, FROM LIGHT TO DARK, FROM THE BASICS TO THE COLORED FINISHED WORK. IN SHORT, THE PUBLIC IS PART OF THE WORK AND ACCOMPANIES YOU IN EACH HOUR AND LEARNS."

—BRUNO FABRIANI

A MULTIDIMENSIONAL ART FORM

Street painting is a uniquely creative expression that has enjoyed worldwide popularity in the last few decades. The art form centers on the creation of images typically drawn with chalk pastels on a city street or pavement; these images usually last only a few days before disappearing from existence. Universally admired in today's cultural climate, street painting has spread all over the globe, inspiring new artists to pick up the chalk and begin for themselves.

What's unique about street painting is its blend of visual art, performance, and process. It's a live-action art form that brings the creative process to the forefront for all to see. Street painters are live performers who expose themselves to the elements and the public. These artists seek to establish a direct connection between their creative processes and those viewing it. Through the public performance, the artist's creative identity is revealed with each painting, giving us a glimpse into the hearts and minds of these unorthodox creators.

Street painting today ranges widely in style, format, and application. Subject matter also varies, and is wide open for creative exploration. Traditional to contemporary, simple to complex, from small one-day paintings completed by an individual to mega-installations that require a team to complete over the course of several days, these works showcase myriad approaches to realizing the artists' visions and ideas with chalk on pavement.

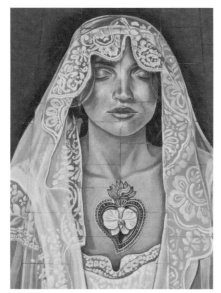

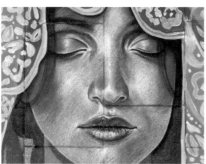

A black-and-white portrait by Valentina Sforzini, along with a detail of the face in process.

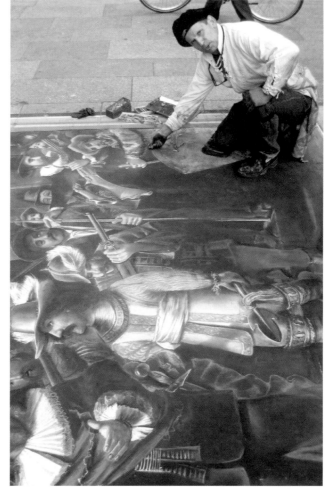

Gregor Wosik not only enjoys drawing in public, but he also likes dressing the part for added fun.

2D OR NOT 2D?

With the appreciation and widespread appeal of 3D street paintings worldwide in the last few decades, many street painters have chosen to work almost exclusively in this format to express their individual artistic ideas. With 3D works come the added bonus of engaging the public in a dynamic manner through interactivity, because such works offer the opportunity to open the street painting up to viewers by allowing them to directly engage with the painting through some type of imagined participation or activity within it. Once in the painting, a photo can be taken to capture the activity, convincing those viewing the photo that, yes, I do appear to be playing chess with the Dalai Lama!

However, with 3D work comes additional problem solving with regard to the design and execution of the art. One must consider spectators' perspective and how that relates to the drawing. Where will viewers stand to see the work? And if they stand at the designated viewing point, will the interactive participant be seen engaging the street painting correctly? Also under consideration is rendering of visual motifs in the piece; will the knowledge of good rendering skills help with the illusion's believability? Absolutely. And what about environment? Will the afternoon shadows cross over the street painting, perhaps ruining the illusion's effectiveness? Quite possibly.

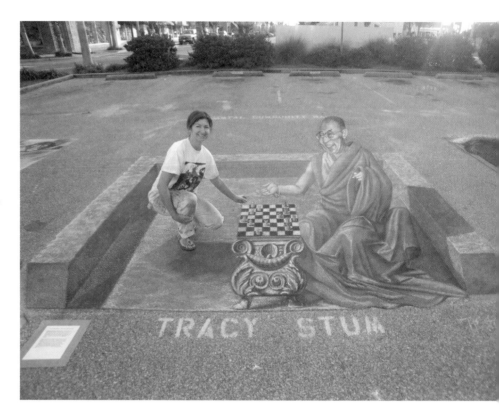

One aspect to consider when designing a 3D image involves understanding proper scale of your drawn image in relation to a real person who will interact in the art, as shown here, where I'm playing chess with the Dalai Lama. Artwork by Tracy Lee Stum.

As you can see, many components need to be considered when embarking on 3D drawing adventures. Whether choosing traditional 2D images to draw, as reproductions or from imagination, or involved 3D compositions, the lessons learned and experience gained from either can be equally as rewarding and satisfying to the street painter.

2D

2D paintings are the traditional way of street painting. These images do not have illusion effects attached to them. They can be anything at all—existing artworks, original portraits and landscapes, photographs, imaginative designs, or abstract images. These designs don't behave in a particular way when viewed through a camera lens, like 3D images do. 2D is a tried-and-true way of re-creating traditional masterworks or honing your chalk techniques on the street.

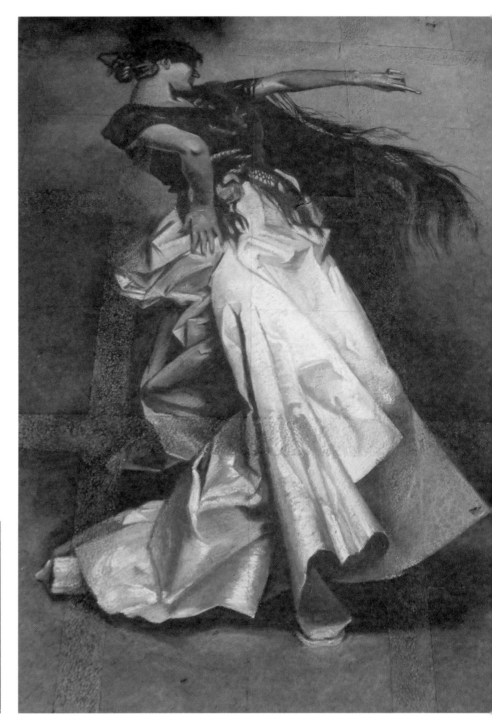

Bee Eater **by Sharyn Chan.**

Spanish Dancer **(after John Singer Sargent) by Tracy Lee Stum.**

3D

3D paintings are illusionistic in nature, appearing three-dimensional when viewed through a camera lens from a predetermined and fixed point in space. We can thank American artist Kurt Wenner for introducing the world to 3D street illusions, as his innovations in the 3D format have inspired subsequent generations of young artists to try the same. Also called "anamorphic" art, these images have a degree of distortion that baffles viewers until they see the work from the proper viewing spot.

Creating a 3D work requires an understanding of viewing geometry and the laws that govern it. The technical aspects can be taught and learned, but a more interesting question might be "How do artists 'see in 3D' so that they can conceptualize a successful painting?" Three-D street painters will use their ability to visualize what they wish to create, then sketch to formalize an idea. Oftentimes the images they design do not exist in the physical world, so they must imagine how their idea would appear if it did exist. Thinking sculpturally can help, imagining how the object being drawn would appear if viewed at a 360-degree rotation.

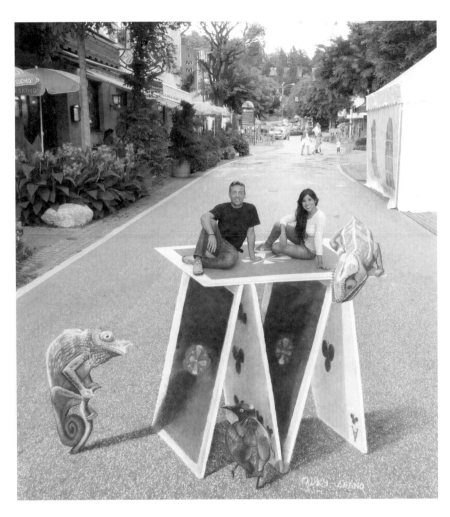

Adry del Rocio and Luigi Legno show us how to play with their 3D painting.

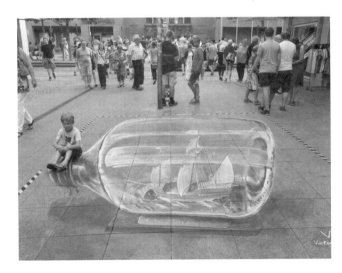

A young child enjoys Victor Puzin's ship-in-a-bottle installation.

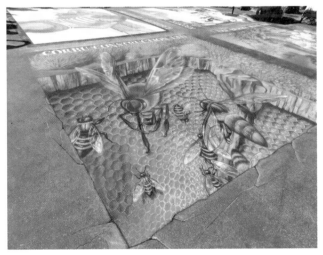

Bee My Honey by Tracy Lee Stum.

4D

4D paintings are the newest innovation in street painting. They incorporate virtual reality applications, projection mapping, and animation as technology components. American artist Anthony Cappetto pioneered this hybrid form of street painting married to technology, inspiring artists to begin creating works that allow for some "activity" in the painting, viewed through a device such as a mobile phone or tablet. Artists Leon Keer and Tracy Lee Stum have successfully used this format to create innovative "moving" designs that bring an extra layer of engagement to their works. Taking a different cue, Cuboliquido incorporates projection-mapping overlays onto his street painting work, so that anyone can see the animated painting without the need for a viewing device.

We can see that new possibilities continue to emerge as artists adapt digital technologies to their creations. Forging ahead with a pioneering spirit, innovative street painters continue to push the envelope and expand the art form in fresh and unconventional ways.

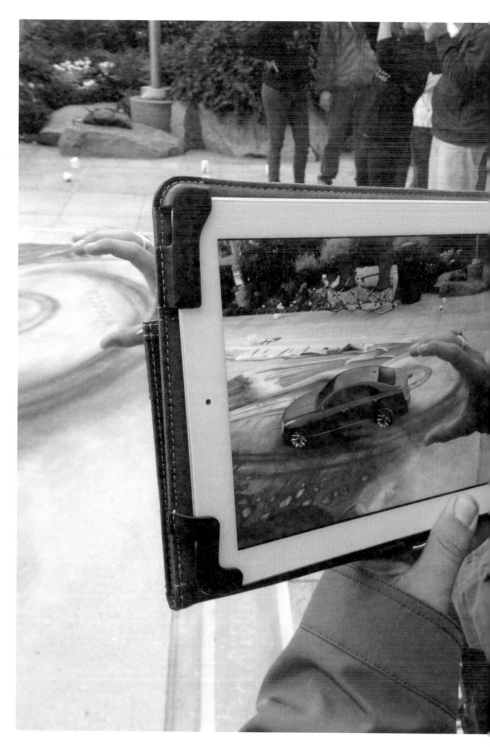

Using a 3D street painting design with an animation overlay that is activated through a digital device app, a static design becomes an interactive film for viewers to play with. In this case, the vehicle overlay was able to drive on the street painting roads, with viewers playing with the car on their tablets and phones. For Cadillac's ATS VS. The World 3D AR Street Painting Tour, USA. Artwork by Tracy Lee Stum.

EVOLUTION OF AN ART FORM

Because of its temporal nature, the act of drawing on the ground can be traced back to ephemeral folk art practices from ancient history. Whether using chalk, charcoal, pigments, dirt, stones, rice or sand, visual folk art practices can be found worldwide in a variety of cultures. Initially created in conjunction with spiritual ritual, ancient cultures such as the Navajo, the Indigenous Australians, and the Buddhists of Tibet and Japan embraced and developed ephemeral art practices still celebrated today.

While the history of street painting is not entirely clear from its distant beginnings, we can imagine that its roots stem from these folk art traditions and practices, when artisans applied their talents in devotion to god and man.

European street painting traditions emerged from ephemeral arts utilized not only for spiritual rituals, but for social ceremonies, festivities and celebrations as well. Artists in Italy, Germany and the UK, have been drawing on the city streets and plazas for decades. The artists were known as *madonnari* in Italy (which translates to "madonna painter"), "screevers" in the UK, and *strassenmalerei* in Germany. Street paintings appear in illustrations as early as the mid-nineteenth century and in photographs in the early twentieth century in the UK, where screevers regularly took to the streets to create chalk pastel works. Throughout the twentieth century street painting endured through periodic appearances in film (such as *Mary Poppins* in 1964) and in popular culture, including the works of Keith Haring in the early to mid-1980s.

Several thousand miles away, we can look to India, Tibet, Nepal, and the surrounding regions for more evidence of evolving street art practices. Born from cultures rich in ephemeral art traditions such as Alimpan and rangoli, artists there have been documented drawing devotional images of Hindu deities on the street with chalk for at least the last fifty years.

The latter half of the twentieth century heralded a new era for street painting, fostering proliferation and expansion. In 1972, the first Incontro Nazionale dei Madonnari, or National Encounter of Madonnari, was held in Grazie di Curtatone, a small village near Mantova, Italy. This event is held as a festival celebrating the Feast of the Assumption on August 15 every year and honors Italy's street painting tradition. The significance here is that street painting was officially recognized as an art form in its own right. The event now attracts artists from all over the world who compete in the 24-hour drawing competition.

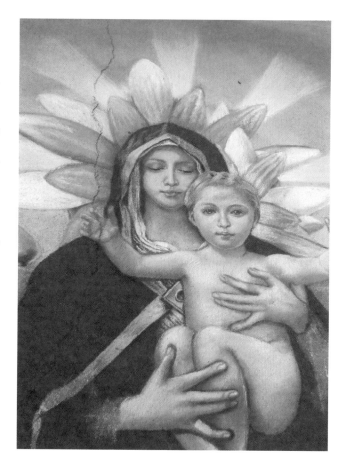

The artist's sensitivity to line and form are evident in this Madonna and Child by Vero Gonzalez.

Robert Guillemin, also known as "Sidewalk Sam," was an early proponent of street painting in the Americas. Having studied at the École des Beaux-Arts in Paris, Guillemin may have first been introduced to street painting in France. He began drawing on Boston and Cambridge city streets in 1973, creating copies of famous masterworks in chalk. By 1980 "Sidewalk Sam" had transformed more than 300 street corners all over the world into ephemeral artworks. Guillemin organized numerous chalk drawing festivals and participatory art events to support arts education and cultural expansion. He believed that art needed to connect with a wider and more inclusive audience, which was why he chose to take his work to the street.

In 1986, the Santa Barbara I Madonnari Festival was founded by Children's Creative Project Director Kathy Koury. Koury developed a unique festival model, which brought local businesses together with regional artists to present the first event of its kind in the Western Hemisphere. Benefiting the Children's Creative Project and developed as a fund raiser for the nonprofit organization, a Santa Barbara County Educational Office arts program, this event takes place annually, typically featuring over 400 local and invited guest artists who come to draw before the Old Mission for three days on Memorial Day weekend every year. This festival opened the door to a wider range of participants by allowing all styles of imagery to be displayed, which proved to be quite popular in the U.S.

In 1994 there were fewer than half a dozen festivals taking place in the U.S. and several in Europe. Now there are literally close to 100 all over the world. The advent of the Internet has helped, with wildly popular, "viral" 3D images from a variety of

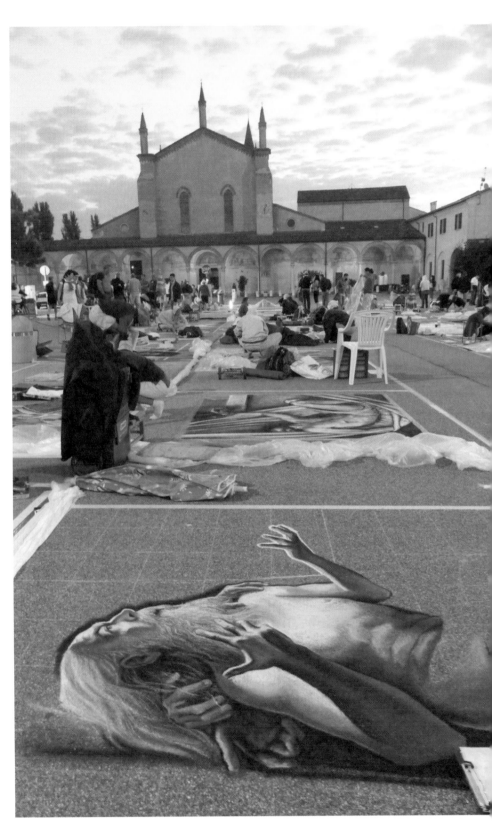

Adry del Rocio's saintly figure appears to be focused on the Sanctuary della Beata Vergine Maria delle Grazie, at the Grazie di Curtatone International Street Painting Festival, in Italy.

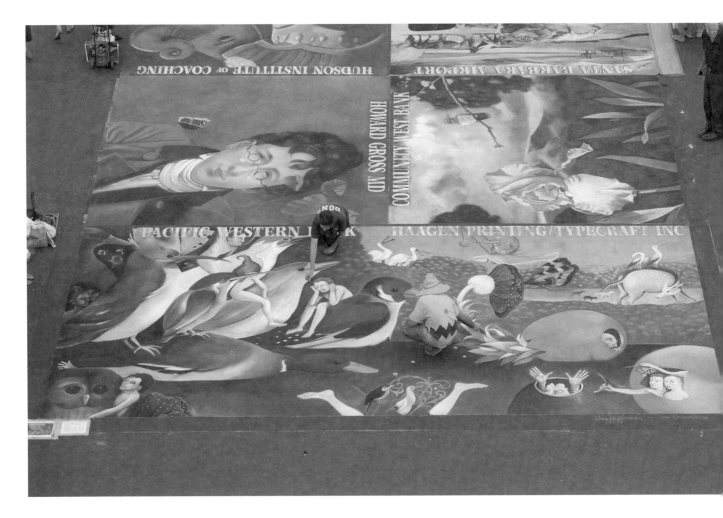

artists inspiring new generations of young artists to "take it to the street." From small communities to educational institutions to large city initiatives, street painting festivals are growing exponentially, bringing artists together for a true meeting of spontaneous creativity.

Today one can see street paintings not only at festivals or designated street painting sites, like those in Italian cities, but also on city sidewalks as vehicles for advertising and marketing, at art galleries and museums, and even on film and television. What was once a fringe folk art practice has now transformed into a global phenomenon that thrives on bringing process- and performance-oriented art making to the public.

Sidewalk Sam summed it up best with his timeless wisdom: "By staying in museums, galleries, and the halls of academe, I felt I was missing the human experience. So I chose to bring art to the street and into daily life. I love crouching on the sidewalk, kneeling at the feet of people, and having art look up to us for a change. I want art to serve people as a natural part of everyday life. I think art should bring people closer to each other and inspire people to a better vision of society."

Along with their friends and fellow artists, Ann Hefferman and Jay Schwartz help transform the entire parking lot of the Old Mission Santa Barbara into a tapestry of color.

WHERE TO FIND IT

We have seen that the art form was first practiced rather randomly on city streets by folk artists, screevers, and *madonnari*. Certain plazas or corners where large pedestrian footfall occurred would probably have been desirable locations for the folk street painter. While some locations were amenable to the artists, many nearby businesses did not support the activity on grounds that it defaced property or was a public nuisance.

In Italy and other European countries, the street painters created associations, which the local government officially recognized and allowed them to work in designated areas approved by the city. The artists could create a drawing, put out a tip cup, and earn something for their day's work. They could then return each day to draw safely and unharassed.

Stone plazas, concrete sidewalks, brick-paved streets, and asphalt parking lots—these are the domains of street painters. Many surfaces work and are found suitable for the practice. If the chalk adheres well, the street painter will work to create a fully realized image. Size is no issue; from a small 2- by 2-foot (61- by 61-cm) image to a large 20- by 40-foot (6.1- by 12.2-m) image, it makes no difference, as time—time to work and time to finish—is the ruling factor.

In Florence, for instance, artists may approach the local Madonnari Association and apply for a permit for a small fee. They are then shown the drawing locations and may work in those spaces as long as their permit is valid.

Ann Hefferman's exquisite floral compositions are one of many incredible paintings that can be seen before the Old Mission in Santa Barbara every year.

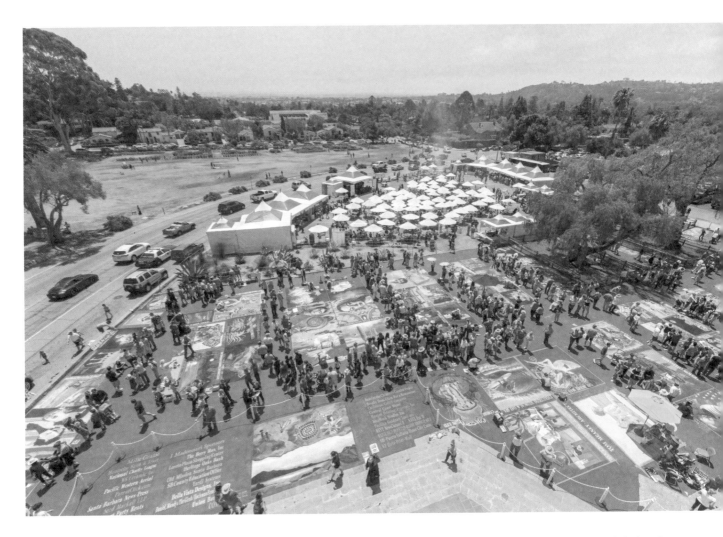

Over the years, individuals and organizations have seen the social appeal of street painting and have organized festivals at which artists could attend and draw their images collectively. The festivals usually received civic support and were sanctioned for these activities. Artists could freely draw with no fear of being fined or told to move away. Plus, it was a great way to gather with one's peers and associates to discuss, enjoy, and foster the growth of the art form. We now see street painting incorporated into fine art biennials and large cultural festivals across the globe.

The public loves street painting, and today street painting festivals and private commissioned works for educational, corporate, and advertising programs are the norm. These organizations have come to value its universal appeal to the masses. With the explosion of interest in 3D street paintings over the last fifteen years, the art form has catapulted to fame and wide acknowledgment in the global consciousness. We now see street painting moving into more remote areas of the world, from South America to Siberia, and from Australia to Africa.

The Santa Barbara I Madonnari Festival, the first of its kind in the Western Hemisphere.

CHOOSING AN IMAGE

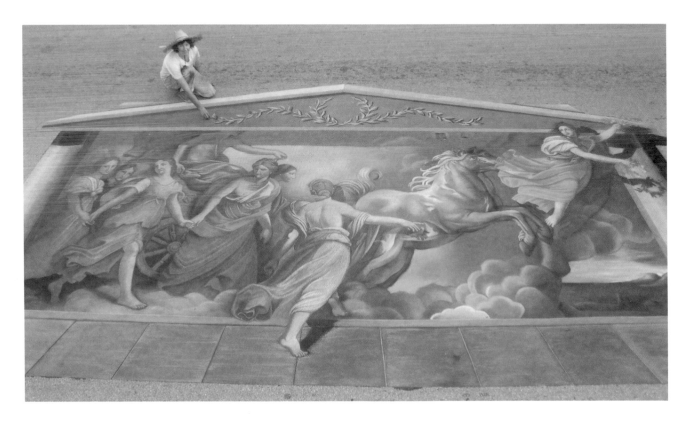

Street painters today have a wide variety of subject matter to select from when deciding on an image to draw. They have access to images via the Internet, photography, museums and galleries, and existing art, and all sorts of material to sift through for the perfect piece.

The Italian tradition focuses on reproductions of masterworks taken from Christian religious subject matter. Think Michelangelo, Pontormo, da Vinci, Raphael, Rubens, Vermeer, and Caravaggio. Works by these Renaissance and Mannerist masters translate exceptionally well into chalk on pavement, and provide for some incredibly beautiful street paintings. The contrast, palettes, and detail in these types of works seem to make these paintings jump off the pavement in vivid color when handled skillfully.

And what better way to learn a skill than through practice? Using existing works to solve visual problems, and to get "practice" drawing things such as fabric, the way light falls, figures, portraits, expressions, architecture, nature, and so on, makes for an enjoyable learning process.

The benefits of working from reproductions for beginning street painters are that they offer invaluable lessons in chalk application and handling, working on a large scale, modulating an individual style, and, of course, moderating their time spent on the image. Time is no small factor in street painting, as the workday usually depends upon the amount of available natural daylight. The artist must learn how to put down what is needed in the time available, whether in three hours or in three days.

I used this composition by Guido Reni to experiment with slight illusionistic effects.

Selecting a suitable size for the street painting is also a design consideration. Knowing how much time is available and how much space, quantity of supplies, and cooperative working conditions one has will often help determine the size of the street painting. Each artist who wishes to complete his or her work may need to consider these various factors before committing chalk to pavement.

With the development of other street painting festivals around Europe and in the U.S. in the 1980s, works of all styles and types began to be adopted as part of the festival format. Today's street painters can create just about anything they can imagine for a suitable pavement piece. Some elaborate designs require a team of artists to execute, which usually becomes an additional exercise in cooperation, time management, and planning for each person involved. Collaborations can open up doors to unlocked potential where there may have been previous limitations. Given a suitable space to work, a clear day, and limitless colors to play with, anything is possible!

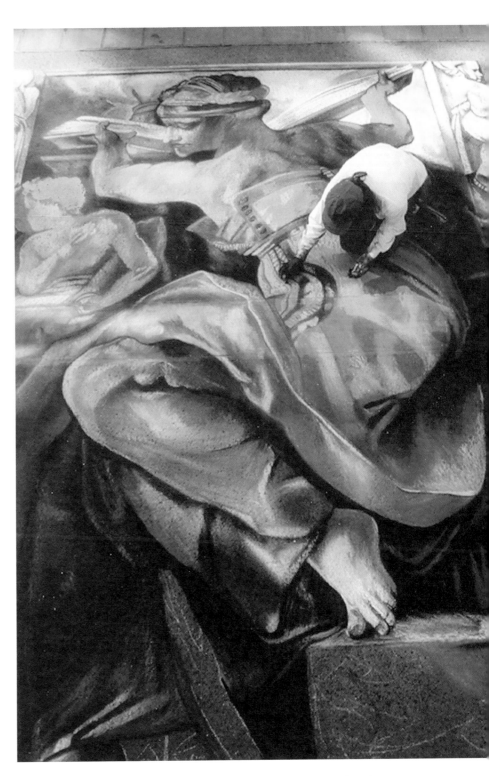

Artist Rod Tryon selected Michelangelo's *Libyan Sibyl* as his subject matter. With only three days to create a finished work, tackling a masterpiece of this scale can teach much about color, form, and time management.

Obaid ur Rahman's small (79- x 79-inch/ 2- x 2-m) pool design is an unlikely surprise on this rooftop.

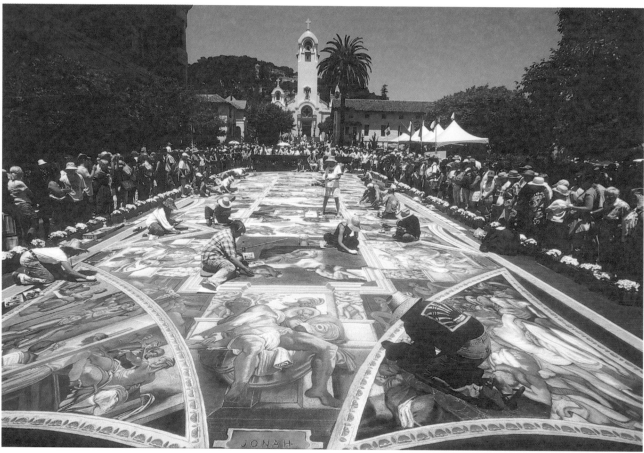

This reproduction of the Sistine Chapel ceiling was created in six days by a team of over twenty-five artists, which I was honored to organize and lead. It was sized at 75 x 25 feet (23 x 7.6 m), approximately half the size of the original work in Rome.

PLANNING AND DESIGN

Artists always ask me how I come up with my designs. I love designing; in fact, that is one of my favorite pieces of the creative process, and I believe that design is key to a successful result. My process is specific and practiced, so designing is quite automatic for me. I draw or sketch every day. When I'm out traveling or going through my everyday life, I may see or hear or read about something that's interesting to me, and I'll either photograph it with my cell phone or take notes about it. Over the years I have gathered enormous amounts of information that I then translate into rough sketches in my "creative time." I may not have a particular project in mind for the idea, but I work it up and keep it logged away for future reference.

ASSESSING LOCATION AND PURPOSE

The first thing I take into consideration is the location of the work and its intended purpose. Location is key, and answering the following questions can help narrow down your possible design requirements. Is it in a busy location and will I have ample room around the piece for viewing? How much space do I have available to me for my piece? How far away will the viewers be from my painting and where exactly will be the best viewing location for them? All of this information helps me better prepare for the kind of art I need to create.

Furthermore, the intended purpose of the art can vary. Is it a work for pure enjoyment or is it a commissioned piece with some relevant content that needs to be considered? Hopefully the best works you will design can fulfill the various

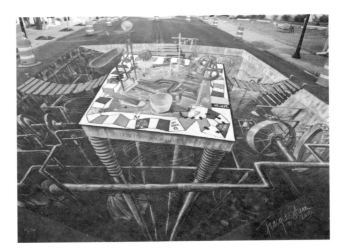

With buildings flanking both sides of the street, this 3D painting of the American board game Mousetrap was best viewed on an overcast day or at midday when the sun was directly overhead.

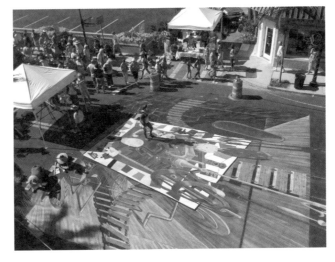

The same image, as seen from above, shows strong cast shadows from the artists, tent, and trees close by. These are things to consider when deciding on the placement and scale of a 3D image.

requirements (personally and professionally) needed for the piece.

Ideally, I like to make a site visit to see my location firsthand in order to evaluate all the elements of the working space. If I can't do that I will request photographs of the site in advance as the next best thing. Of course, you'd want to have a variety of photos from different viewing locations to help you work out the best placement for a piece. I also make sure to inquire about

other objects that may interfere by creating unwanted shadows on my piece. Are there buildings, structures, trees, or light posts close by that may cast a shadow on my piece at the time when it's opened up for photographs?

LIGHT AND SHADOW

Since lighting and shadows are an essential consideration for 3D images, when on-site I use a compass along with a great app called Sun Seeker on my smartphone, which shows the projected path of the sun at any given time at any global location. Used by cinematographers in the film industry who shoot outdoors, this app is helpful in understanding how to plot exactly where the sun will travel and how that will impact my painting on location. You really don't want the sun in front of you when it's time to snap photos of your work because this causes glare on most surfaces, so knowing the direction of sunlight and how shadows work accordingly can help you understand where best to locate and orient your painting for optimal photographic results.

PORTABLE STUDIO

Sometimes the design work needs to be completed or adjusted on-site, as the actual location may be somewhat different from photos provided. As a way to accommodate this I recommend creating a portable digital studio to take with you when traveling. This includes a laptop and/or tablet, a portable printer, and a portable projector. This way you have design autonomy, with everything you need on-site to create or adapt as needed.

This street painting of a floating girl by the artist Cuboliquido is best seen at night. Cuboliquido explains, "Sometimes it happens that the subject, as if by magic, is already there on the spot and is only made visible. But you do not always have the opportunity and the time to know and visit the location before having to plan or think about what to paint. As it happens, you discover that what you had in mind instead is perfectly adaptable to that type of environment."

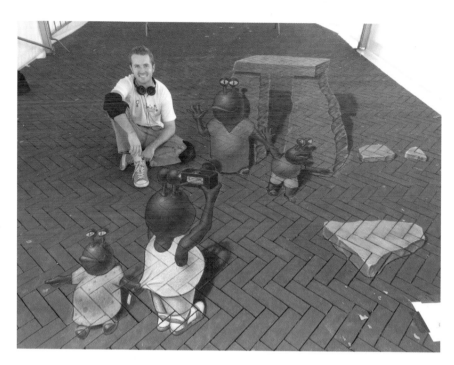

In this piece, Chris Carlson cast the shadows away from his characters, so the illusion will work with anyone who interacts with the painting. Carlson says, "When I'm creating a painting that people will be posing with, I try to keep in mind where the sun will be in the sky around the time I finish. Then I will place my shadows in a way that corresponds with the natural shadows cast by people posing with the artwork."

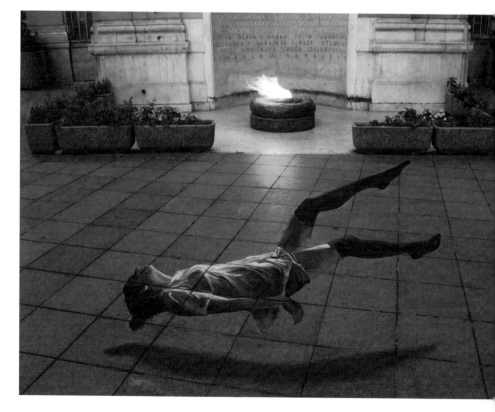

DEVELOPING AN IMAGE

Once I have all the information I need, I start associating the theme of the piece with basic concepts, perhaps going back to one or two that I had previously sketched up in my free time. If I find a fit—concept with approach—I then start working on this idea in earnest. I determine which approach would suit the concept best: Do I need to build a model? Do I need photographs of specific components? Can I purchase existing usage images online? Do I need a digitally rendered image to inform on shape and lighting? When I have these questions answered, I finalize a design that I can work with. This doesn't mean that I'll always faithfully follow the design I come up with, as I'm known for changing or editing images directly on-site for improved results, but at least I have a basic guideline that my clients and I can feel comfortable with.

My philosophy on the working process centers on using the proper tools to achieve the best results possible. As a professional, using a sketch or drawing, a photo, a built model, or a digital rendering are all relevant, valuable tools to get you from point A to point B. Ultimately, the final work needs to be completed by the artist's hands, which is the culmination of the entire process.

Artist Julio Jimenez used Photoshop to create this collage image of an antique car. By placing a sepia-toned background behind it, this car feels like it's driving out of the past onto the sidewalk!

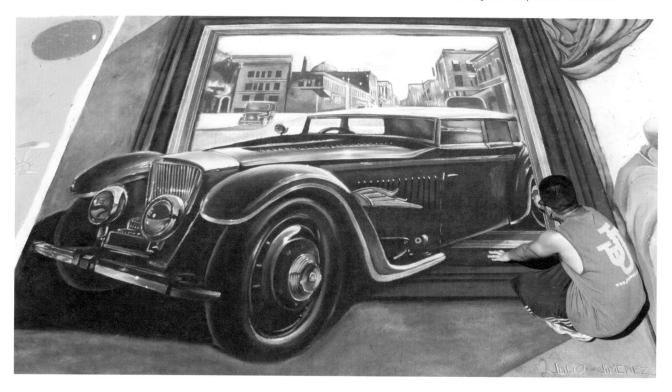

SKETCHING

Sketching from life, from imagination, or from photo references is a great place to start your design concepts. Try a few loose thumbnail sketches to get a feel for several ideas at once. Play with this process and push the boundaries of what you think you can do. I find that the best ideas come from giving myself full range of play with the creative process, so have fun with this!

After you have a few design sketches that you feel good about, you can then proceed to fine-tune those selected with more fully rendered and resolved versions. Variations in format and presentation can be seen in the following selections.

Working out the final layout of a painting may involve not only the idea sketch itself but also some engineering of the sketch to correspond to the actual size of the intended street painting.

By using photography, sketches, value studies, and other visual notes, Gary Palmer plays with all sorts of options to achieve the composition or design he will ultimately execute. For sketching, he likes to jot down his images and impressions in a small sketchbook that he carries while traveling. He keeps the ideas loose, which he then references for more fully realized concepts he wishes to pursue. The sketch shown is based on Van Gogh's painting *The Potato Eaters*.

A final color sketch by Tracy Lee Stum for a client presentation.

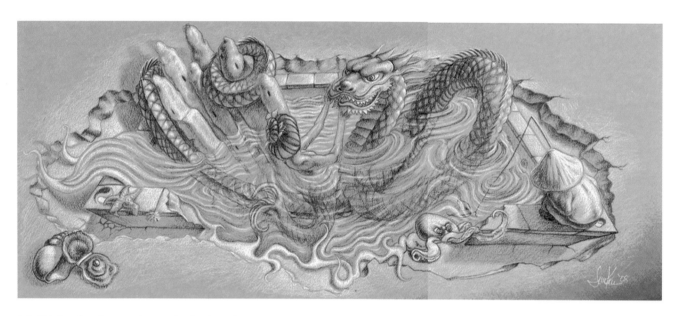

Julie Kirk-Purcell prefers a tonal approach to her design layouts.

Ann Hefferman created a black-and-white sketch on tracing vellum to use as a final reference for a painting. Hefferman offers, "My most important tools for designing are tracing vellum, a No. 2 pencil, a photocopier, and a light source. I also use a light table when I can."

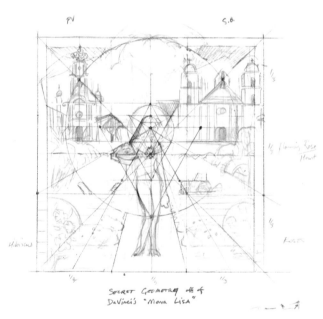

To design his 2D images, Phil Roberts uses his knowledge of divine proportion, also known as the Golden Ratio, which is based on the methods of Luca Pacioli and Leonardo da Vinci.

WORKING MODELS

Building models can be very effective when creating a mockup of a design concept. The artist may need to understand clearly where and how the light will fall on the imagined structure, so a simple built model will often do the trick. It helps create an understanding of the scale of shadow shapes and the subtleties of the lighting as it hits the objects being rendered. Additionally, a full-scale color model can help an artist visualize exactly how the work will need to be set up on-site.

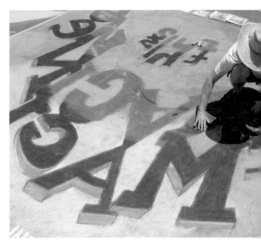

Street painter Mark Wagner not only sketches freehand but also creates digital drafts on the computer to work up ideas for compositions. He often creates composite images and montages of various elements that he then incorporates into a final work. In addition, he creates a foam-core model to investigate lighting and shapes prior to sketching, and to replicate how shadows and forms will work when viewed in 3D. This process is a terrific way to achieve accuracy on a complex dimensional design.

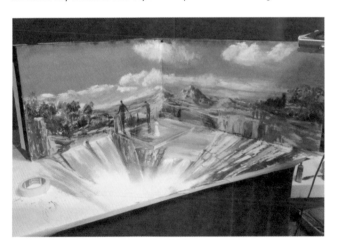

Gregor Wosik uses an incredibly detailed full-color model to show the scale and location of his piece's design elements.

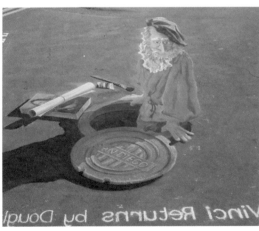

Douglas Rouse set up a costumed model in his studio to develop detailed visual content for his street painting.

DIGITAL RENDERING

Digital rendering has become a widely used method of constructing imaginary scenarios that may not be available solely through photography or other reference sources. If the artist truly wishes to design an authentic work with correct light sources and placement, there are dozens of 3D computer graphics programs to use that will allow for this. These can be of tremendous value to an artist who wishes to design something that simply doesn't exist in real time.

Sara Mordecai uses her skills as a professional graphic designer and painter to create digital compositions of her street painting images. See page 147 to see the work in process.

Mark Wagner uses digital renderings to create various components of his designs.

Cuboliquido combines sketching, notes, a suggested palette, and type in this computer-rendered composite.

PHOTOGRAPHY

Lots of artists I know make a habit of carrying their cameras around with them. However, now we *all* carry cameras around with us thanks to increasingly effective cell phone cameras. Capturing objects or locations that would work well for a future composition is extremely helpful in establishing and maintaining a visual library for possible concepts.

In the event that you aren't able to capture with your own camera that particular element needed for your design, online photo sources (some free and some paid) such as morgueFile, photos4artists, Getty Images, iStock, Shutterstock, Dreamstime, Corbis, and Adobe are a great way for graphic designers and street painters to find that needed content. The "pay for image" sites allow you to use an image with certain publishing limitations, depending on the fee you pay.

It's important for all artists to make sure they are using certain images according to copyright usage restrictions or laws, to avoid any legal issues with their designs. It's up to the users to make sure they are adhering to all international copyright regulations.

Here are some online sources for free photos.

- freeimages.com/
- totallyfreeimages.com/
- images.google.com/hosted/life
- openclipart.org/
- public-domain-photos.com/
- karenswhimsy.com/
- public-domain-images/
- freeimages.co.uk/
- everystockphoto.com/

Michael Las Casas couldn't photograph an astronaut for this piece himself, so he found one online.

PHOTOGRAPHY FOR 3D

When working in the 3D format, an artist should consider the height, distance, and proper orientation for figures and objects as related to the viewing point. For example, if your scene takes place below ground, you'll want to consider how far above the figure or object you should have the camera placed for viewing, then try to replicate that placement in your reference photographs.

In the images on this page, we see how Wayne and Cheryl Renshaw have used photography as a design component for a 3D street painting. If the lemur in Wayne's photo is going to be seen at 5 feet (1.5 m) from the viewing point, then the lemur should be photographed 5 feet (1.5 m) away.

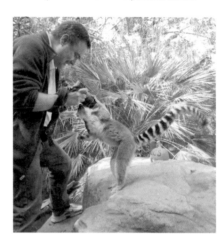

The Renshaw artist team went to the zoo to capture their subject matter: a few very curious lemurs.

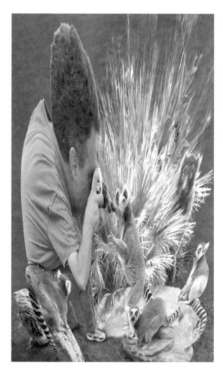

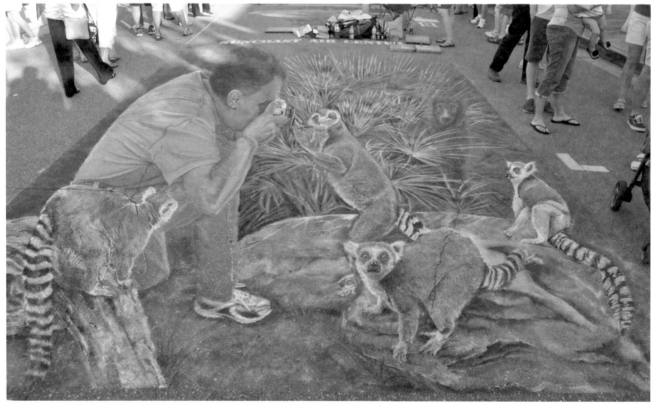

The finished street painting.

COMBINING DESIGN METHODS

An artist may use any number of these methods to actualize a design. From thumbnail sketching to photographic references, digital composing to model building, these methods all serve to inform the artist of an accurate and believable design. This can be particularly relevant when working in the 3D format, as many factors come into play when searching to understand how an object or a scene works with lighting, viewing location, proportion, and so on.

Here I provide an overview of a fairly typical design process for a 3D image.

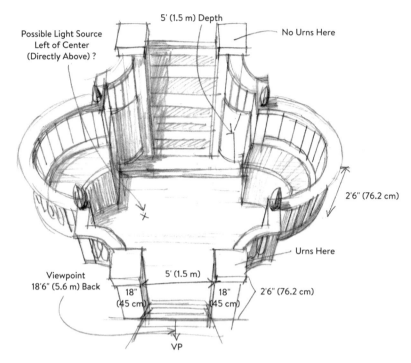

Step 1: For the initial stage of the design, I worked out a black-and-white sketch with key dimensions and the light source.

Step 2: For the second phase, digitally rendered components were created based on the black-and-white sketch to assess proper lighting and placement of the imagined architecture.

Step 3: I photographed models in the various positions needed for the composition.

Step 4: I located accurate reference images for specific costumes.

The finished piece: *Medici Garden* **by Tracy Lee Stum.**

CHALK PASTELS FOR STREET PAINTING

There are a number of suppliers who provide street-ready chalk pastels to the street artist. Because a street painter is oftentimes grinding through lots of chalk on the pavement, many tend to stick with the economical suppliers rather than spend a lot of money on higher quality pastels that will wash away in a matter of days, if not hours. Suggested vendors include Mungyo (known as Koss in the U.S.), Eternity Arts, Mount Vision, and Dick Blick. These manufacturers provide a satisfactory-grade pastel with a good palette range suitable to most pavement surfaces at a modest cost.

A selection of chalk pastel and supplies for street painting.

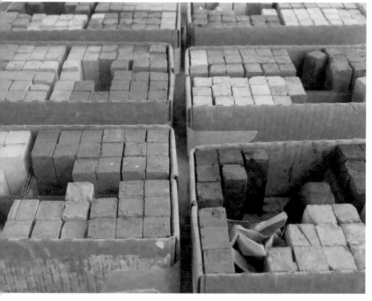

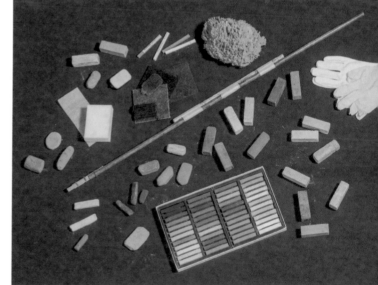

HOMEMADE CHALK PASTELS

The best street chalk pastel is definitely the homemade version. These can be customized with variations in the ingredients to create a pastel that is tailored to the artist's specific working techniques. By experimenting with the various pigments and binder blends, artists can customize their palette to create high-quality color variations that don't exist in the manufactured palettes. Additionally, homemade chalk pastels are quite economical in the long run, as you can make large batches at one time that will last for the entire year. This translates to a big cost difference per stick that will provide significant savings for the artist.

Lots of recipes exist for making pastels that will also work on the street. An interesting recipe used by many street painters over the years and developed by Kurt Wenner includes beeswax, linseed oil, soap, and other ingredients. See page 152 for an easy, standard recipe that yields excellent pastels for all three art forms discussed in this book.

For instructions on how to repurpose broken chalk pastels and pieces, see page 65.

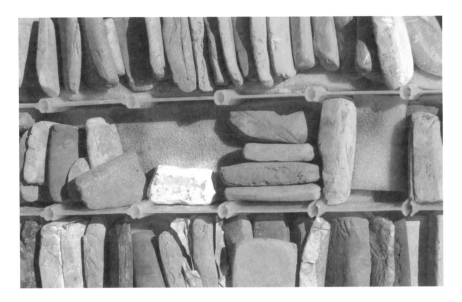

Artist Alice Crittenden makes her own street painting pastels and creates some interesting shapes for a variety of uses.

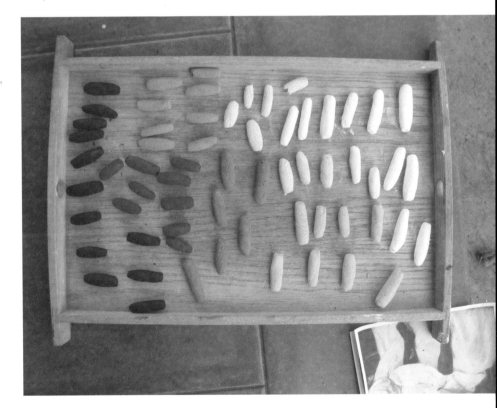

Sharyn Chan's homemade chalk pastels for street painting.

TOOLS FOR WORKING ON-SITE

Working on the street requires some specific tools or gear to help you battle the elements and get the work completed successfully. Not only weather but also surfaces can be hard on the street painter because temperatures on the ground can be much warmer than the ambient air. Being well prepared and equipped will make the process that much easier!

I have a street painting kit that I always keep replenished and ready to go for festivals and events. Over the years I have tried a wide variety of tools and materials to help my working process become more streamlined. I've found tools that work for all sorts of street painting needs. Some have stayed in my kit and others have been removed when I felt I no longer needed them. The basics remain. Each artist customizes his or her own kit, so the choice is yours.

In addition to a basic palette of chalk pastels, an artist might consider the following tools for a street painting kit.

- Chalk line and powdered chalk, for making a grid or other straight lines

- A measuring tape, for proper measuring of grid, viewing point layout, etc.

- A spool of masonry string, for 3D images

- Straightedges and rulers. These are great for making clean, straight lines and edges on borders, geometric shapes, and so forth.

- A drawing stick, for working while standing. This really saves your back! See page 140 for more information.

- Gloves, both cotton and latex. When used together—with the latex gloves worn over the cotton ones—they

create a cushy, comfortable support for your hands and fingers when blending and otherwise working on the surface. They also protect your skin from heat, sun, and the materials you are working with. Another benefit is that they keep sweat from running down your hands and onto your painting if it's really hot outside.

- Carpet squares and plastic styrene sheets, for blending on rough surfaces

- Felt erasers, for correcting mistakes and blending large areas on rough surfaces

- Various types of tape: masking, blue, gaffers, antiskid, duct

- Sponges, for cleaning up any areas that need correcting and eliminating unwanted grid lines

- A spray bottle, for spritzing water

- Baby wipes, for easy cleanup

- Laminated reference image. This is another great tool—the lamination keeps your reference clean and its crisp edge can be used to mask off straight areas.

- A kneeling pad, knee pads, foam cushion, or padded contractor pants, to save your knees and other parts on hard and hot working surfaces

- Cardboard, for protecting completed areas of your drawing if it rains lightly, and also for standing or sitting on while working. Cardboard doesn't disturb chalk very much at all, so if necessary you can carefully place it over completed portions of your drawing to rework hard-to-reach areas.

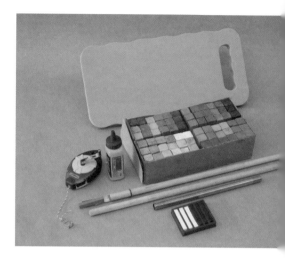

Some of the basic supplies for street painting.

- Hat, sunscreen, and sun umbrella. If you'll be out in the sun for a few days creating your piece, be sure to have sun protection with you.

- Suitcase or rolling bin, for easy transport

- Viewing lens or camera and tripod, for 3D images (optional)

Wearing latex gloves over cotton gloves provides extra protection for your hands.

WEATHER

You've got to plan for weather! Rain, damp conditions, wind, sun, and heat will each have its effect on your working schedule and your painting. Take precautions appropriate to the selected location and to protect your image or workload.

For example, if you're aware that rain will be an issue, plan to create an image that can be completed before the bad weather appears. Or you might situate your artwork on higher ground or under an overhang to protect it. Also recommended for suitable image protection are thin plastic dropcloths combined with cardboard sheeting. I like to place large 4 by 8-foot (1.2 by 2.4 m) sheets of cardboard directly over the painting, then cover the cardboard with the plastic dropcloth. Use duct tape or other heavy tape to secure all edges fully. Always use cardboard and plastic sheeting a few feet (1 m) larger than the actual image in the event you have some seepage under the edges.

And it's important for you to take care of yourself as well. As artist Ann Hefferman says, "Street painting is an endurance feat. Stretching, hydrating, and eating are mandatory in order to endure the elements of weather and unconventional body positions for prolonged periods of time."

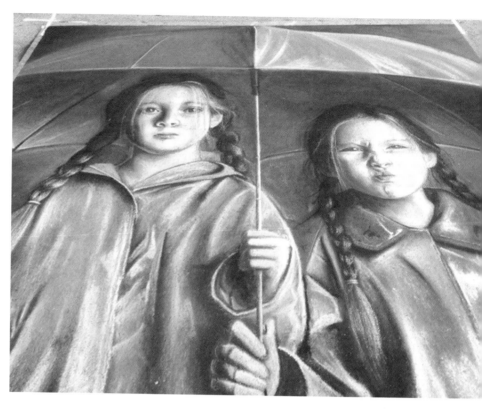

Nate Baranowski's painting accurately reflects how street painters feel about rain!

As rain can come at any moment, a portable dryer or leaf blower may sometimes come in handy for drying out a wet working surface, as demonstrated by artist Wayne Renshaw.

CONSTRUCTING A 3D STREET PAINTING LAYOUT

Laying out a 3D street painting requires specific skill and knowledge regarding design and the rules that govern these illusions. The basics can be learned quickly through practice with simple geometric shapes; however, a firm knowledge of advanced drawing and painting skills helps tremendously when creating believable and deceptive illusions.

HOW 3D WORKS

There are several key elements to consider when designing 3D images that will assist you in creating an effective illusion.

- **The viewer:** The person who will be looking at the image.

- **The viewpoint:** The place where the viewer will stand to see the illusion, most often times located at eye level.

- **The surface or ground plane:** The surface where the image is drawn, be it street, sidewalk, plaza, etc.

- **The subject:** The image that will be drawn on the ground plane.

- **The picture plane:** An imaginary, two-dimensional surface upon which our subject is located. This is the plane that we use to "project" our image onto the ground plane. It is situated at the bottom edge of the ground plane, where we will be drawing.

Step 1: We start by setting up our working area, by placing the viewer while indicating the viewpoint, and the subject as they relate to each other on the ground plane.

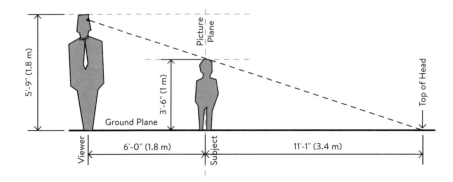

Step 2: If we draw a dotted line from the viewpoint to the top of the subject matter all the way to the ground plane, this will show us where we need to establish the top of the subject matter on the actual ground. By using a measurement system of units, we can exactly determine the distance from the viewer where this place will be.

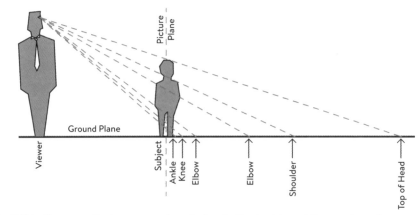

Step 3: Using the same method, we can see where all other significant points meet the ground as well.

Some general rules that pertain to anamorphic projection are:

1. There are two approaches to creating a 3D design:

 - Images that sit on or above the ground plane. These can be figures and objects that sit on the pavement, or anything that floats or hovers above the surface.

 - Images that sink down below the ground plane. These can be the classic hole in the ground with a receding image down below, recesses in the pavement, and so on.

2. All elements of this design setup are variable, including the height of the viewpoint, the distance of the viewpoint from picture plane, the scale of the image, and so forth. Remember, that when you adjust one of these components, even a small amount, it will change the geometry of the anamorphic projection, requiring you to make corresponding adjustments throughout. For example:

 - Should you decide to bring the viewpoint closer to the picture plane, your subject will become shorter, making the anamorphic projection smaller.

 - Should you decide to raise your viewpoint a few feet, your subject view would change, showing a more overhead view of the subject and shrinking its projection length.

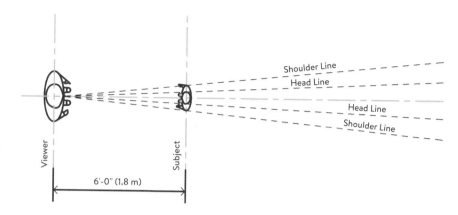

Step 4: Now let's take a look at the overhead or plan view of this setup. By drawing the imaginary lines out to key points on the subject matter, we can plot where these lines project into space.

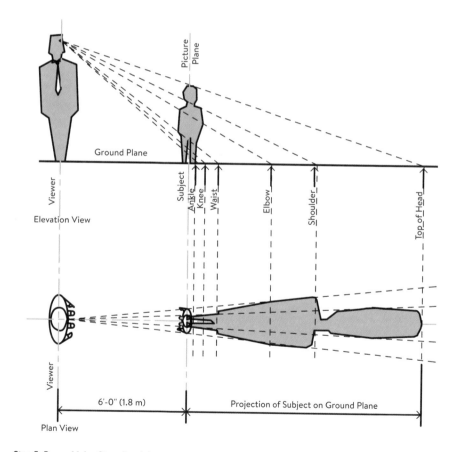

Step 5: By combining Steps 3 and 4, we can see exactly where on the ground these points should fall. The image that results is called the anamorphic projection.

3. The taller the subject is, the longer the projection will be. Tip: Using a predetermined ground plane size will help you establish how big your picture plane image can be. Additionally, you can use a viewing platform to raise the viewpoint higher, thus providing opportunity to place taller items in a more confined ground area.

4. Anamorphic projection tends to distort images from the viewpoint out: the farther away the image is from the viewpoint, the more distorted it will become, typically becoming much more elongated than normal. For example, items to the left of the viewpoint would tend to fan out or lean left, and items that are right of the viewpoint would tend to fan out or lean right. The only vertical line would be at the center line of the drawing from your viewpoint.

When I create my images and am using models or real objects as reference, I typically photograph the subjects from the exact angle I wish the viewer to see them in my drawing. For instance, if I have a seated person in my design, I will photograph him or her from the exact height and distance that I will be setting up my on-site viewpoint. This way the reference images appear more believable when incorporated into the overall design. Again, this being variable, you would need to photograph the object or person from a new position if you move or adjust your viewpoint to a new location.

THE VIEWPOINT

When approaching the pavement where your image will be situated, one of the first things to do is assess the entire area for the best viewing position. You've got your design ready, you have your supplies, and now you are ready to get to work, but you do need to establish where your viewer will stand to see the illusion properly.

Many people ask me how to engineer a 3D street painting. I always tell them that the viewing point is crucial because this is where all the magic happens. Consider the height of the viewers' eye from the ground, as well as the distance from the painting where you'd like it to be. These points will determine how much distortion your painting requires.

This is illustrated in situations where the viewing point is fairly close to the painting. If you move the viewing point even just a few feet (1 m), this will alter the level of distortion needed to make the work correct. You'll want to make sure you have plenty of room for the viewing point, especially at a festival where long lines can develop to view the painting.

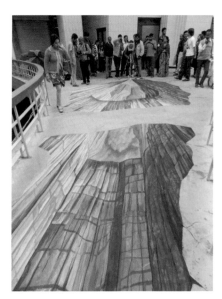

Here is another street painting showing how the distortion works from the back of the painting.

X marks the spot! Establish your viewing point and your painting placement in relationship to that. Look for the sun path (see page 108) so you know where shadows from participants will fall. Ideally, you want to make this consistent with the shadows in your design. If you need to shift the placement of the work to accommodate this, do it. You'll be glad you did. Keep in mind that the sun is not in a great location for photos when it's directly in front of you, as this creates glare on the painting surface. Try to keep the sun situated so that glare does not become an issue.

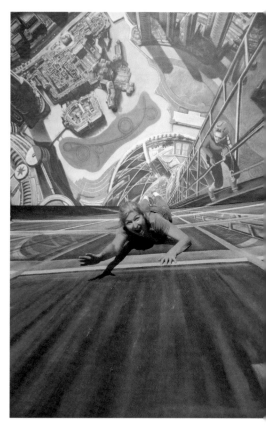

Abseiling the Burj Khalifa illustrates what happens with a ground-level viewpoint. The vanishing point is on the wall directly in line with the viewing point. The anamorphic projection here happens in reverse: extreme distortion happening closer to the viewer, with diminished scale increasing as one moves closer to the back wall. The art on the back wall is designed to the vanishing point to create a sense of vertigo. Artwork by Tracy Lee Stum.

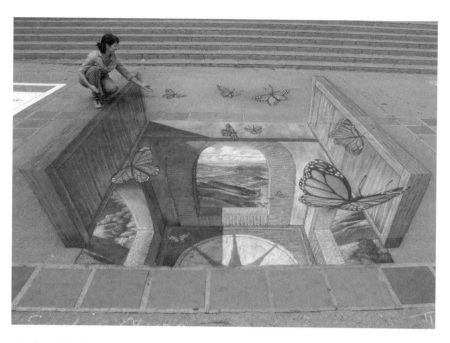

My painting, *Butterflies Over San Luis Obispo*, as seen from the correct viewpoint—in front of the painting.

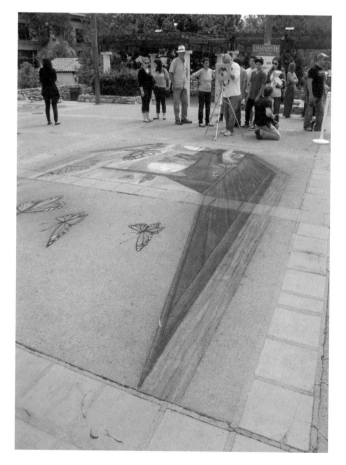

The same painting, seen from the back of the work. The distortion is easily seen from this angle.

Lay out your design using a grid, a string, a camera, and/or a viewing lens. Stepping back to periodically check your progress at the viewing point will help make sure the images are distorting properly.

Consider using a premade stencil or cartoon for lettering, labels, logos, and branding details. It will save you a lot of time and energy when on-site.

Remember that basic design elements, which are parallel to the ground plane, should be drawn as seen from above. For example, when drawing a circular fountain in perspective, be sure to draw a circle exactly as you would see the top plane from overhead. You should not create artificial distortion in this case, as the camera will automatically place it into proper perspective view. Adding the vertical planes, which all recede back to your viewing point, can be placed with your string anchored to the viewing point.

Alternate Viewpoints. One way to create unique experiences with your design is by changing your viewpoint to an unexpected location. I have created a small series of images based on very low viewpoints, which are almost at ground level. These designs require a wall and floor combination layout to maximize their effectiveness. (See *Abseiling the Burj Khalifa*, page 124)

THE PERSPECTIVE GRID

There are quite a few ways to create a perspective grid for working out design ideas. You may want to create a quick grid using simple geometry on paper as a sketch, or use a 3D software program like SketchUp Pro on your tablet or computer, or even mark off a full-scale grid on your floor and photograph it from your viewpoint. It's really up to you.

The perspective grid replicates how the image will be seen on-site or through a camera lens. This is the grid you'll want to use for designing. The keys to making a perspective grid properly are the height of the viewing point and the distance from the bottom edge of the painting. These two dimensions create that one point in space where your art will cease to be an abstract distortion and become a magical illusion.

This digital comp shows an architectural setup in the perspective view.

An easy way to work with a grid is by taping one off on the ground. This way you can place people and items in the space to see how they will work in your drawing.

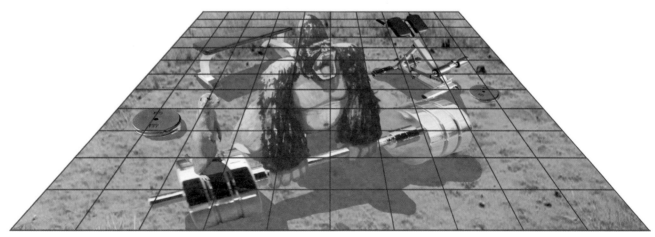

Example of a computer-generated perspective grid with image design included, courtesy of Julio Jimenez.

THE ANAMORPHIC GRID

When the design work is done and you're ready to transfer your idea to the street, using an anamorphic grid as a reference is helpful when drawing complex organic shapes or detailed compositions.

This grid is the "map" you can reference to make sure your distortions are placed properly for an effective illusion. It's the way you get your perspective grid view onto the pavement. As long as you trust the distortion, your pavement piece will look exactly like your perspective grid design when finished.

The main difference between the perspective grid and the anamorphic grid are the shapes and sizes of the grid squares. You'll notice that the perspective grid squares diminish as they go back into space, thus creating the sense of depth.

The anamorphic grid is made up of equal-size squares in perfect alignment with each other. This is really the perspective grid as if you were seeing it from directly above. They are one and the same, only viewed differently.

Whether using a hand-drawn sketch or the computer, you can make your perspective grid, including the image, into the anamorphic grid by pulling up the back edges of the grid until all the squares are of equal size. Using the Transform tools (Scale and Perspective) in Photoshop will help you achieve this very easily.

The same image as seen opposite, this digital comp is the anamorphic view or map that would be used for reference when drawing the actual piece on the pavement.

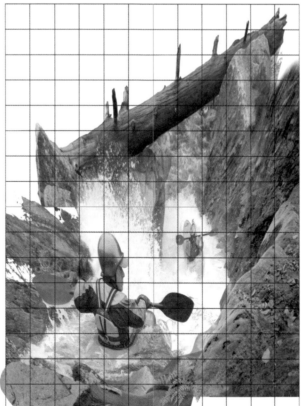

An anamorphic grid map, courtesy of Wayne and Cheryl Renshaw.

SETTING UP YOUR LAYOUT

Now that I've discussed the basic mechanics behind 3D illusions, let's see how they all work together.

The perspective grid is what I use to mock up design ideas and concepts. It's a fast and easy way to check your design to see how effective it will be. Many street painters now use software programs to draft their images, which saves time and offers versatility for easy corrections and adjustments. If you don't have the capability to work with a computer, you can try marking out a grid on a working surface and then photographing it from your desired viewpoint. Print the photo and use the perspective grid layout as a basic guide for sketching your designs.

Once you have your perspective grid and image worked out, you will need to transform it into an anamorphic image. This step by step, courtesy of street painters Wayne and Cheryl Renshaw, takes some of the mystery out of how the grid relates to the viewing point of 3D illusions.

Wayne states: "Even though we don't know how tall the grid we are projecting will be, we can figure it out. Where the line of sight crosses the picture plane will be the height of our grid. Furthermore, we know that things that are in the picture plane can be scaled. In this case, scale does not mean that they are 'full size'; it means that measurements that are not distorted can be made in this plane."

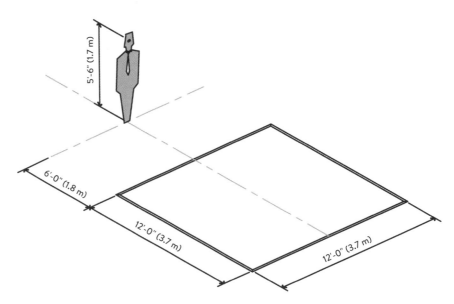

Step 1: As you can see in this diagram, there is a line of sight that projects to the top of our floor plane area as it passes through the picture plane. The distance between the floor and this line represents the height of our grid. You'll notice that this distance is now divided into 12 equal units, which corresponds with the actual length of our drawing area on the floor, which is 12 feet (3.7 m).

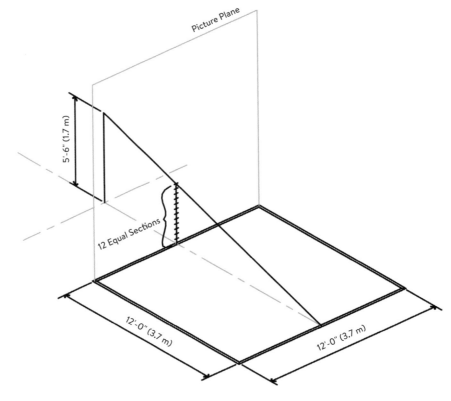

Step 2: Projecting lines directly through each of these unit marks creates the proportional widths of the horizontal grid lines on our floor plane.

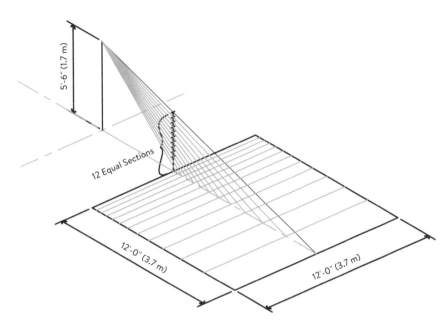

Step 3: Because the vertical and horizontal dimensions along the picture plane are not distorted, we can use the same unit of measurement along the floor to create 12 equal units there.

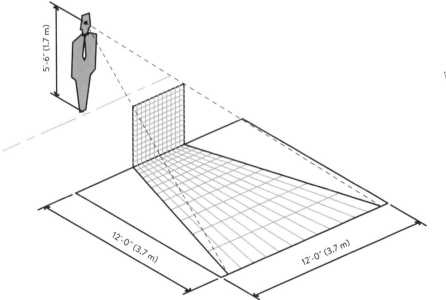

Step 4: We now have an anamorphic grid, which is how our picture plane would appear on the ground.

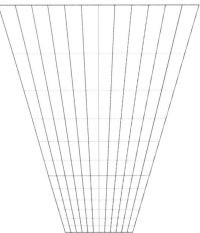

Step 5: The actual 12- x 12-unit grid in anamorphic projection.

Now we know how our image on the picture plane works to get to the floor plane, but how does this information all into a workable reference for actual street work? For this next step we can use Photoshop to distort our anamorphic image accurately.

Remember that any change in your viewing angle will change how the picture plane image projects onto the floor surface. That means you would need a new grid for each viewing adjustment you make.

It may take some practice, but with careful preparation, the final image will appear as an illusion in three dimensions.

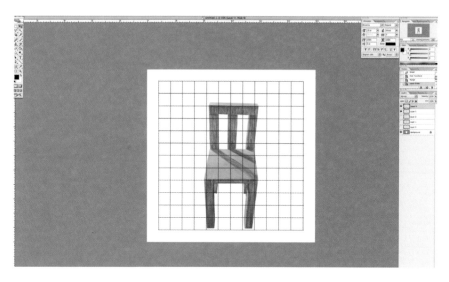

Step 1: Open your image design in Photoshop and create a 12 x 12 square grid, saved as a PDF. (Saving your grids as a PDF allows you to scale them as needed to work with your design resolution.) I then place it over my chair design on a separate layer.

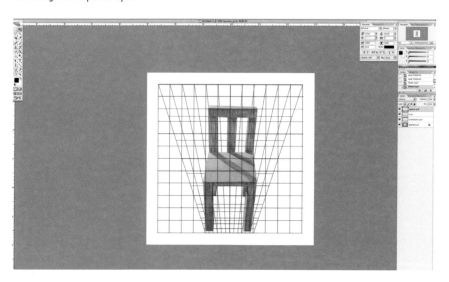

Step 2: Next, I add my anamorphic grid image as another layer, this time beneath both the image and square grid layer. I line them up at the top and bottom so they are registered on these horizontal lines, making sure the center vertical line stays registered as well.

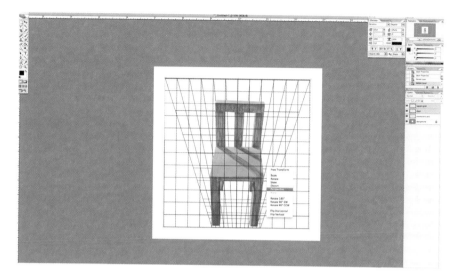

Step 3: Link both the image and square grid layers together. This allows you to stretch both images together. We want to "match up" the two grids, while stretching our image at the same time. As you can see I am using the Edit >Transform >Perspective tool. You may also need to use the Edit > Transform > Scale tool as well. This will easily stretch your image to its proper distortion.

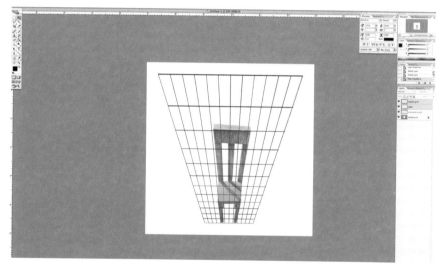

Step 4: Here are the image and square grid transformed to match up with the anamorphic grid.

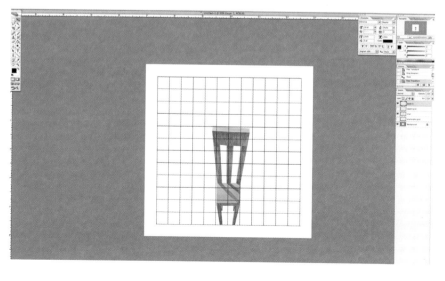

Step 5: At this point you can add another square grid over the image, lined up at the top and bottom of your anamorphic grid and then turn off the other grid layers. This is your drawing map, which be transferred to the street to fit into your 12- x 12-unit drawing area.

PREPARING THE SURFACE

A variety of surfaces confront street painters when they are asked to make drawings at festivals or events. While black, fresh, clean asphalt is a real luxury for street painters, we don't always get that, so learning to adapt to all sorts of working conditions is great practice. If I am going to work on a surface I have not previously encountered, I will make sure to do a test on the surface to see whether my chalk will work properly. Sometimes the surface does not accept the chalk so readily, which means some additional preparation might be required.

Most concretes, asphalts, and paver surfaces work well. Some pavers have sealants on them, which create an adherence problem with the chalks, but you won't know that until you test it out. In some regions of the U.S., pavement surfaces are composed of shell aggregate and stone bits, which chalk just hates! What happens is your painting will look speckled with white or gray or black bits where the chalk refused to adhere. No one wants that, so in those areas it is acceptable to prepare the surface first with a base of diluted tempera paint or sugar water, which creates a barrier surface that the chalk does like.

A brick paver surface that's acceptable for street painting.

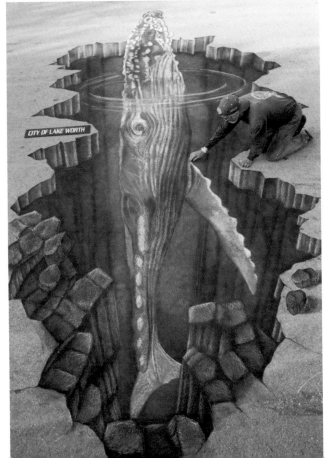

Rod Tryon demonstrates how well chalk works with typical street asphalt. His 3D piece transforms the street into a deep water cavern.

TEMPERA PAINT

Tempera paint is widely used at U.S. festivals with chalk adherence challenges. It's easy to prepare and use because it dries rather quickly in direct sunlight. It creates a good working surface for chalking over and because it is water soluble, there is no issue with permanency.

The basic tempera recipe is one part tempera (which can be toned to match the pavement for a less noticeable result) with three parts water. This mixture can be rolled on with an ordinary paint roller. Usually two coats is optimal but one slightly heavier coat works just as well.

After the tempera base dries, the artist can go about working on the surface as he or she normally would. Tempera is nontoxic and can be easily cleaned up with a wet/dry vacuum for proper disposal. If left to the elements and traffic it will wear away in time, just like chalk.

SUGAR-WATER MIXTURE

In Europe, artists have been using a sugar-water mixture, or even Coca-Cola mixed with some pigment, as a base for chalk drawings. Artist Bruno Fabriani suggests using a can of Coca-Cola mixed with some burnt sienna pigment to create a base imprimatura that will be suitable for classical figures. The stickiness of the soda will disperse a bit with the addition of the pigment, but it still works well for a transparent layer.

If the asphalt or pavement is very rough and needs some correcting, adding some PVA glue and some small amounts of pumice powder into the soda mixture will work very nicely. This diluted mixture should be sufficient to fill up small cracks and accept chalk when dry. Plus, it cleans up rather easily with rain or water.

Additionally, for rough holes and gaps in the pavement, a matte gaffer tape or anti-slip stair tape can work very well to camouflage these flaws. Both accept chalk, so they work well for disguising surface blemishes that may need to be covered.

Don't use a damp sponge to make corrections on a tempera- or sugar water–based image, as this will remove the base. Instead, use a melamine magic eraser, but be sure to use a dust mask to avoid inhaling unwanted chalk particles or irritants.

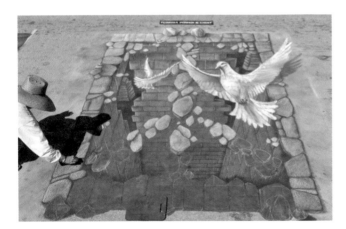

Rod Tryon applied a coat of black tempera on the pavement prior to his chalk work.

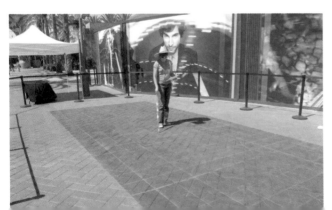

Brick pavers prepared with a tempera base.

Artist Ketty Grossi uses sugar water mixed with powdered pigment to lay down her base design and prepare slick surfaces to accept chalk.

SMOOTH SURFACES

Surfaces that don't work so well with chalk are slick, smooth surfaces without any tooth or texture, such as marble or granite. Sealed or painted surfaces will also give problems with adherence. Some stone slabs that are smooth work extremely well with chalk, such as the pavers on the streets of Florence, Italy; however, the artist would need to test the surface first before determining which method to use to prepare the drawing surface.

ARTIFICIAL SURFACES

When working on a pavement surface is simply not possible, there are a variety of surfaces one can use to make a successful chalk painting.

Canvas. One option is a canvas surface, which can be prepared in advance and then completed on location. Use a medium- to heavyweight cotton duck canvas (#10 or #12) for this if you plan on having people step on your painting. If you'd like something a bit less thick, you can opt for a scenery muslin, which is much thinner and less expensive; however, you will need to gesso both the front and the back of the muslin to give it more support to withstand any public interaction.

You'll have to tape down all the edges of the canvas artwork so it's flush with the floor surface. Double-stick tape or carpet tape on the back of the canvas will usually do the trick.

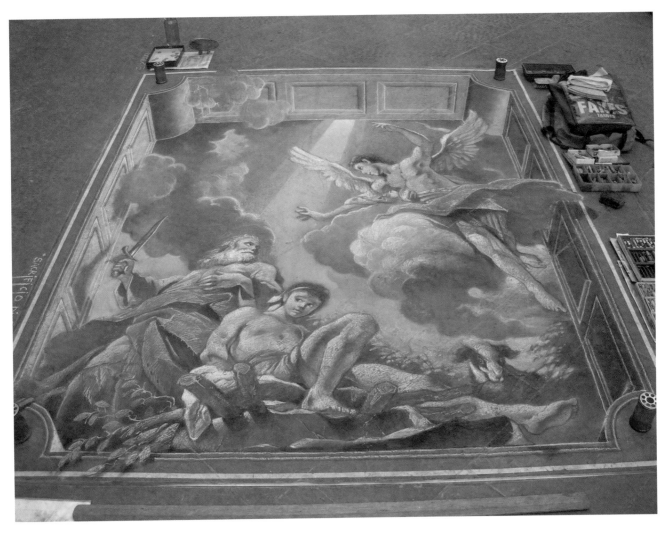

Tomoteru Saito has been working on Florence streets for many years and gets terrific results on this stone paver surface.

Asphalt Paper. Asphalt-coated roofing paper is fantastic when prepared properly and has a slightly more permanent result. I used this method on several large projects in the past, including my 2006 *Da Vinci Code* Guinness World Record painting and my 2010 Winter Olympics indoor chalk wall mural. Both yielded a satisfactory working surface that really resembled working on asphalt streets. I developed my own working "recipe" for preparing asphalt paper as a suitable working surface.

Asphalt paper ready for use. This product comes in rolls and can be found at most roofing suppliers. I glue it down to a wood panel and lightly sand off any loose particles.

> **Step 1:** To begin, adhere the asphalt paper to wood panels or the wall, which should then be sanded to knock off all the excess grit that is loosely adhered.

> **Step 2:** After this, coat the paper with one layer of black gesso and let dry.

> **Step 3:** Apply a coat of black or toned tempera paint. Chalk doesn't adhere to gesso very well, so I always use tempera for a final coat.

The result of this process is an industrial-strength pastel paper, which can be sized to your preference. I created 4- by 8-foot (1.2- by 2.4-m) panel sheets for my *Da Vinci Code* piece and a full 14- by 40-foot (4.3- by 12-m) wall for my 2010 Winter Olympics wall mural project.

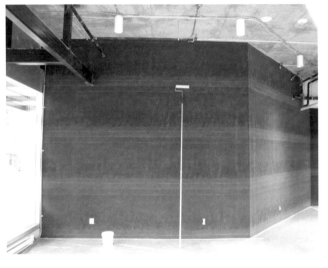

Once the paper is glued and sanded, a layer of black gesso is applied to seal the surface, followed by a layer of black tempera, which will accept the chalk.

Wood. Another option for an artificial surface is a wood panel or platform. Although it is not ideal, as it is raised off the ground and you will have edges to contend with, it can be a good solution for movable images or where rain or water runoff could damage a work on the street.

I recommend using a slightly toothy finish, with some texture, so the chalk has something to grab on to. If needed, prepare the surface with tempera or sugar water so the chalk will adhere better.

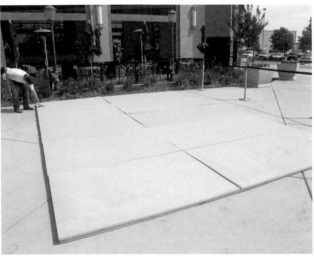

Assembling a wood platform for a chalk drawing.

TRANSFERRING A DESIGN

This section provides an overview of the process of transferring artwork for street painting to the intended surface.

GRIDS AND LINEAR TRANSFER METHODS

Using a grid or a geometric line layout of any sort is a very basic method for transferring a sketch or concept to a full-size painting. The grid is comprised of equal units marked on the vertical axis and the horizontal axis. A variation of this is a diagonal layout, which begins with a large X on the drawing and then is progressively reduced to smaller Xs by adding more diagonals.

To use the grid method, take your final image and place an equal-unit grid over the image (for example, 2-inch or 5-cm squares). The equal unit grid is then also created on the final working surface, scaled up to the size (maybe 10-inch or 25-cm squares) that will fit the total size of the painting you wish to create.

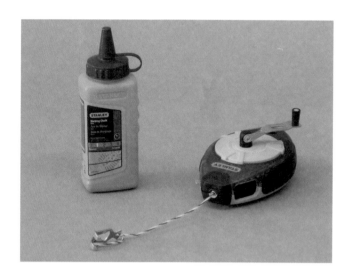

A standard chalk line and chalk.

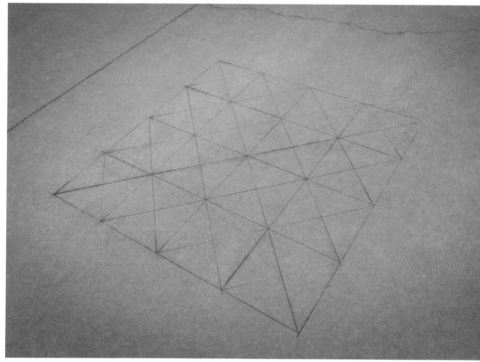

The grid is created with a chalk line (also called snap line in street painting slang), which delivers chalk to a string that is then placed from point to point and "snapped" to deliver the chalk from the string to the surface. It's a basic construction tool and can be found at most home improvement stores.

STRING LAYOUTS

A string grid is another method of laying down a grid without having residual chalk lines to erase later. Simply create the grid using lengths of string that are taped down at the measured unit points. This can be worked over with chalk or paint and then easily removed. Some minor touch-up may be required after the strings are taken away.

The string grid is placed on the working surface.

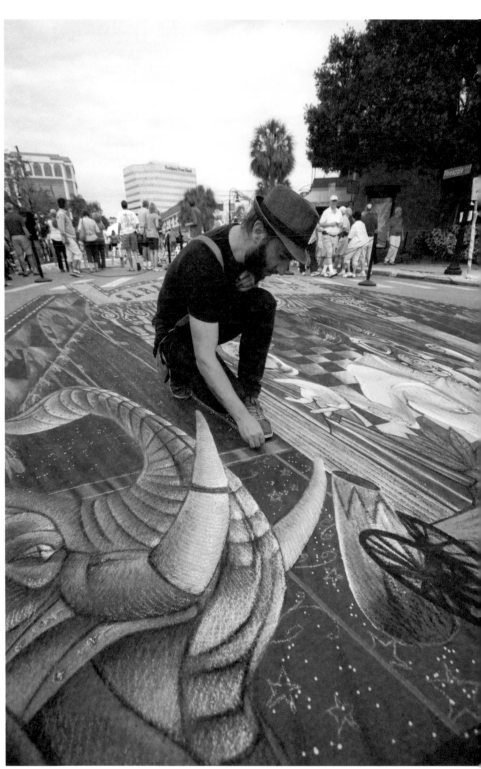

Artist Cuboliquido uses a string and tape to lay out his composition on-site.

TRACING OR POUNCING A CARTOON

The Tracing Technique. As discussed on page 49, using a large cartoon to transfer an image is another great technique. The artist can use either a projector or a grid to create the sketch at full size on a piece of paper. This paper is then taken to the street painting site and placed down on the surface as desired.

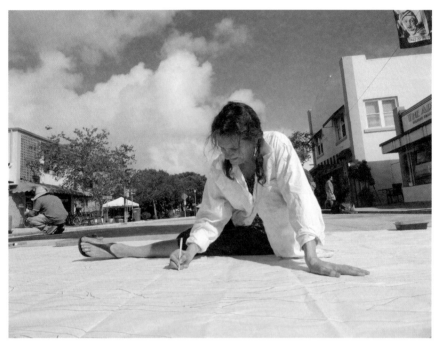

The tracing technique. (Above) Ann Hefferman uses a projector to enlarge her original sketch to the size needed to fit her street painting square. (Above, right) She applies white chalk to the back of her cartoon, turns the cartoon right side up, then draws over those lines to transfer her image. (Right) The result of the cartoon transfer process: a solid design that's easy to see and ready for color.

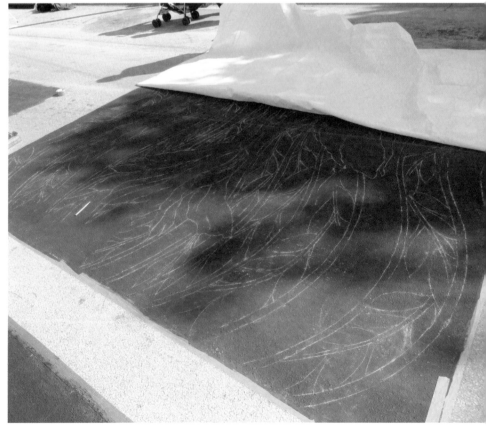

The Pouncing Technique. By using a pounce technique, where small, perforated holes are punched through the sketch lines and chalk is rubbed over them, the image is transferred to the surface beneath. Alternatively, you can skip the pounce completely and simply apply chalk to the back of your cartoon, then sketch over the lines on the front side, which will transfer the image to the surface beneath. The benefit of this method is that it can be prepared in advance of drawing day and it allows for fast transfer on location when you may not have a lot of time for the drawing transfer step.

To speed up the pounce technique, try an Electro Pounce machine. This time-saving, easy-to-use tool is a great investment for your professional studio.

The pouncing technique. (Top) Jennifer Chaparro applies chalk over her cartoon to deposit color into the perforations. **(Center)** When the cartoon is removed, the chalk has been left on the surface beneath, creating a dotted outline of the image. After sketching her image onto the pavement, Chaparro recommends rubbing in the line with a sponge, to set it and keep it from blowing away. It darkens the line, so it's easier to read in the camera for assessment. **(Bottom)** Chaparro working on the image within the outlines.

STENCILS AND TEMPLATES

Using a stencil or template for components of your design is another method employed by artists on-site to make the drawing process go a bit faster. When restricted time is an issue, making a stencil for elaborate borders or design elements can really save a lot of time in the long run.

Cardboard, heavy paper, foam core, transparencies, and vinyl stencils all work well with pavement, and most can be reused if handled carefully. This is a great way to create text or logos that need to be very specific. Spray chalk works well with vinyl stencils and can be washed away just like the rest of the drawing.

DRAWING STICKS

A centuries-old tool widely used by the scenic and mural painting communities, a drawing stick is a lifesaver out on the pavement. It behaves like an extra-long pencil extender. The benefit is twofold: you can see your image from a relatively wide view, which helps with proper proportion and scaling, and it saves your back, eliminating a lot of work that would otherwise be done down on your knees in a bent-over position.

The drawing stick can be a simple wooden dowel or a piece of light bamboo, at a comfortable length to hold while standing, most typically around 4 feet (3.6 m) in length. A piece of chalk is then taped or tied to the end of the dowel or, in the case of the bamboo, split at the top to allow a piece of chalk to be inserted into the opening. You'll have to rubber band or tape the bamboo tight on the chalk so it doesn't slip out.

An example of a stencil pattern as used on a painting by Sharyn Chan.

Phil Roberts sketches in his composition using a drawing stick.

I use a portable collapsible drawing stick for travel, crafted by my friend and street painter Sharyn Chan. It's two pieces of a 42-inch (107 cm) wooden dowel, which has been cut in half, with a metal tubing center support to connect them for assembling. It has a two-sided bracket attached to the end with small washers to hold the chalk in place. This tool goes with me everywhere and breaks down to easily fit into a suitcase or bag.

Mark Wagner uses a large piece of chalk taped to a broomstick to create his drawing layouts. He notes that he can make easy spirals, work on a playground, or use it in the beginning to transfer an image onto the street.

STREET PAINTING TECHNIQUES

Perhaps it's inevitable that the wide range of subject matter appearing in street painting images today would require a variety of drawing techniques. An artist who is new to street painting may not know exactly how an image will look once it's completed, or even how it will develop, because he or she is unfamiliar with the techniques for handling chalk and pastel on a pavement surface.

Discovering the preferred means of laying down chalk and working it into something authentic is part of the joy of the process. Certainly, a variety of methods can be accessed to achieve certain effects—blending, scrubbing, layering, hatching, contouring, or even splattering. These techniques can vary, depending on the image as well as the conditions under which it is drawn. Fortunately, street painters must learn to adapt to less-than-hospitable conditions when making their art; finding the way to do that is a big part of the journey.

Using color and technique to tell your story is pure joy! Being able to bring your design to life requires skill with the pastel so your effects are in alignment with your design concept. On the pages that follow are some basic ways to apply chalk for successful and beautiful results.

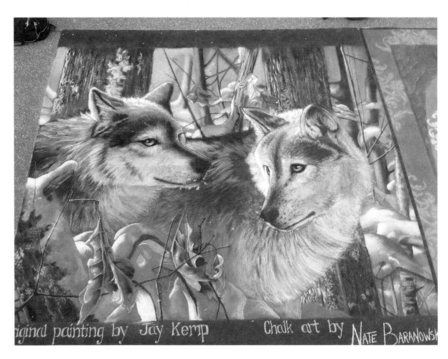

Free Spirits **(after Jay Kemp) by Nate Baranowski.** Layering pinks and blues creates the effect of a cold winter scene.

Contour drawing—lines placed and shaped to follow the planes within a subject—can be seen in this work by Vera Bugatti.

LAYERING

One of the features of my work that contributes to the depth and clarity of image is the color layering technique. I usually see many other hues in a color I am referencing and allow myself to play with these variations through layering the chalk. The vibrancy of this technique occurs because all colors used show up in the final work, creating a richness overall.

A layered approach usually involves a combination of blending and contour drawing techniques. The artist applies one or more layers of chalk on top of a unified base color, usually with those final layers left as loose marks, with little or no blending. Using the color beneath as a starting point, the artist will use whatever mark is needed for a particular area—a line, a block of color, a smudge—just about anything that will result in the desired effect. The representation of depth in drawings that feature layering increases as additional layers are applied: the richly applied colors show through each other and are optically "mixed" by the observer.

Remember to gradually diminish the amount of chalk you apply with each consecutive layer. Also, I don't like to blend the subsequent layers, but rather will leave them drawn as is. Contour drawing or cross-hatching techniques also work well with this layered mark-making approach.

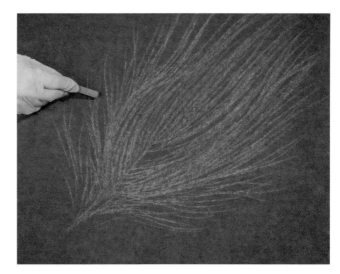

Step 1: To begin, select a color in a medium dark value and apply just enough to get the basic shape down.

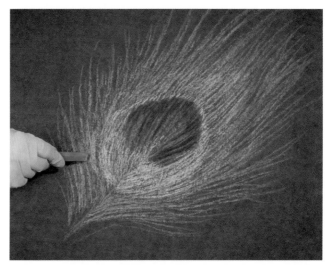

Step 2: Begin working in other color variations in lighter values, keeping the coverage at a reduced percentage.

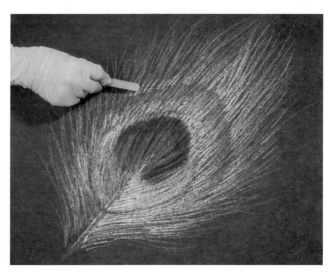

Step 3: Continue with even lighter values, with less coverage than in the previous step. At this point you can add darks as well.

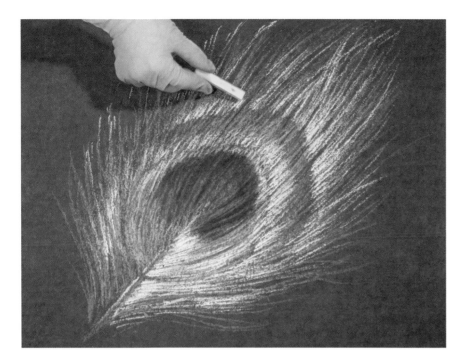

Step 4: Add the lightest values to pull out the brightest highlights.

Julie Kirk-Purcell creates a vivid frog with subtle color variations by using a layering technique.

The Conversion of St. Paul **(after Caravaggio) by Luigi Legno.** Building layers of subtle color brings this classical piece to life.

HATCHING AND CONTOURING

The opposite of blending (see pages 146–147), hatching is achieved by making lots of marks on the pavement, then leaving them as is, with little or no blending. This method requires a steady hand, as line work is the preferred manner of delivery. Multiple lines, mainly parallel to one another, are applied close together to cover the pavement. A field of color can be laid down with systematic patterning, placing one line next to the other, to create the first layer. Then a second layer of lines is laid down, usually more or less perpendicular to the first. This starts to form a network of color that still maintains looseness and openness. Pavement can be seen beneath but tends to recede as more layers are applied.

Contouring brings this method of application into play by using marks that curve or bend to correspond with the planes of the subject being drawn. Lines will appear to wrap around or curve within an area in an attempt to reflect the various plane changes within a subject.

Step 1: Begin with loose line work moving in one direction as a base layer.

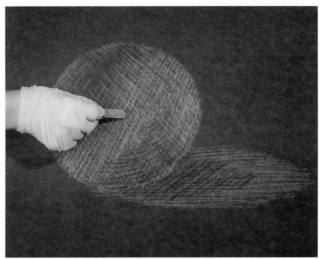

Step 2: Using a lighter value, work another layer of loose lines in a direction that is up to 90 degrees in orientation from the first layer.

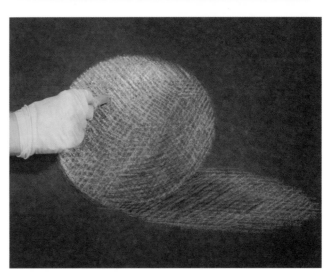

Step 3: Add subsequent layers of shorter strokes in a contour pattern that works with the shape of the object.

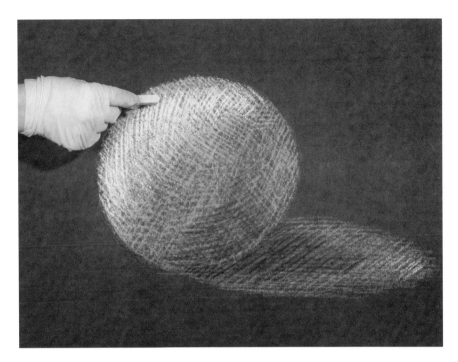

Step 4: Add lightest values for highlights.

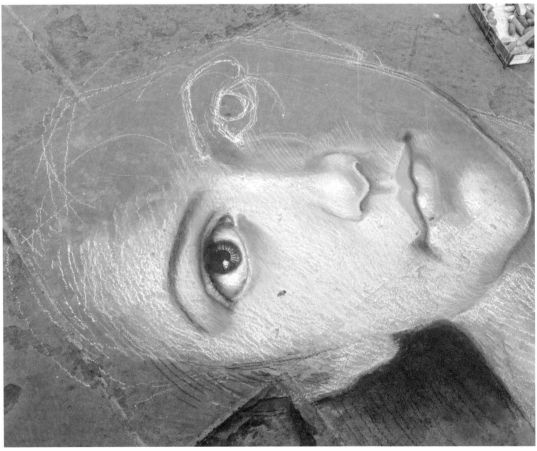

Keeping his work very loose, Tomoteru Saito achieves depth and form with the hatching technique in this portrait.

BLENDING

The blended chalk technique can stand on its own, or it can serve as a preliminary technique for artists who prefer to delay mark making until the final pass of an image. Blending usually requires the ability to create subtle gradations of color, using tone and shade to create variations in value. After using the broad side of the stick to lay down a smooth and flawless layer of color, many artists use their hands to rub it into the pavement, while others use carpet squares, small pieces of polyethylene plastic, or a standard chalkboard eraser. Edges are respected, but you won't see much line work in paintings that feature this technique. A soft and subtle feel is the result.

Step 1: Apply the base colors evenly, not worrying about covering every part of your working area.

Step 2: Using a carpet square, felt eraser, or piece of styrene plastic, begin blending the entire layer so that all areas of the surface have chalk applied.

Step 3: Begin working the various colors together with a blending tool, smoothing out the surface as you continue.

Bold colors become shadows in Adry del Rocio's palette. Del Rocio explains, "If you want to do a natural shadow, use more colors than gray or black. Blue and purples are basic, and for the skin purples, greens, burnt sienna, reds, and burnt umber are a very good option. Try to use two or three of them but not in the same area. Lose the outline between the colors. Do not texture the shadows, leave them smooth, but do the opposite with the highlights. When you try to emphasize a light, leave the light colors with texture in small areas."

(Top and above) Sara Mordecai uses a blending technique to create her smooth, colorful works.

This brilliantly colored portrait by Adry del Rocio seems to jump off the pavement at us.

ALTERNATE TECHNIQUES

Mark Wagner discovered a spatter technique by accident. He used dirty water to mop up some blue chalk lines and when the water dried, it left an organic, "old" texture that he fell in love with. He now rubs a wet towel with chalk, twists it, and lets it drip onto the street. It creates a non-hand mark, looks random and old, and can easily be drawn on or rubbed into.

MAKING CORRECTIONS

The good news is that just about every "mistake" you make in street painting can be corrected fairly easily. Simply pull out your sponge and spray bottle and wipe away the area that you wish to correct. Erasers are fine, but a little bit of water works wonders!

A spritz of water from the spray bottle can also help control very dry chalk that is easily blown away. After working, spray lightly and let dry. Working into the chalk while it is wet can also help "lock" the pastel down onto the surface.

If you find you've been heavy-handed and put too much chalk down, creating a lot of extra, unwanted dust, here's a quick solution. Take a baby wipe, open it up fully, and lay it gently over the dusty area. Pat lightly and remove. This will pick up any extra chalk dust you have without damaging the layer below.

GETTING ATTENTION

Getting started on the full-color rendering of your street painting is where the real fun comes into play! Since it is a performance, you will probably want to consider how best to engage your audience rather quickly. You're having fun drawing, so why not let the audience in on that fun as well?

For portrait and figurative work, faces always grab the audience's attention. Starting with a focal point, such as the eyes, will create a dynamic where the audience wants to return again and again to see your progress. They love the creative process as much as you do and being able to see the development of something recognized is a surefire way to keep the audience engaged. Artist Mark Wagner explains, "I like to focus on one part of the drawing that shows that I can draw. This is important for the artist when thousands of people are looking at what you are doing. We all judge things in the moment, and if you see someone can draw well, you know the rest of the piece will look good."

When it comes to 3D works, the minute viewers can see the line drawing standing out against a dark background, they get it. That makes them curious about the rest of the work—how will it look in color?—so they will return to see more of the process.

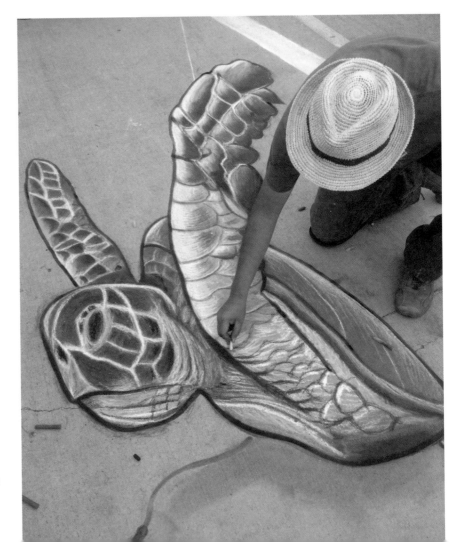

Mario Belmares starts his piece by focusing on a brightly colored turtle to draw immediate attention to his work.

VIEWING THE ART

When artists have finished their work, they then offer it up to the public for enjoyment, commentary, and consideration. Cleaning up all the tape around the edges, the supplies that have been strewn around, and the last bits of stray chalk, artists can then sign their name to the work if they like, and take some photos for a record of their performance.

Video clips are a great way to capture the process of making a street painting, with time-lapse videos being the standard for live-action creation. These are great for compressing forty hours of work down into a quick three-minute overview that demonstrates the magic of a painting coming together.

When setting up a video camera to capture a time lapse, make sure you place the camera on a tripod that will allow the entire scene to be captured. The artist will be moving around the painting during the course of the process, so you definitely want to capture all that movement. Be sure to tape the location of the legs of the tripod on the ground and mark the height of the camera so that you know where to place it each day for consistency.

Since most 3D images do require viewing devices to properly see the illusion at work, artists today use viewing lenses, Fresnel lenses, and cameras set up at their drawing for the public to view the art through. Large or small, these lenses allow the public to see the illusion as the camera sees it.

A viewing lens setup.

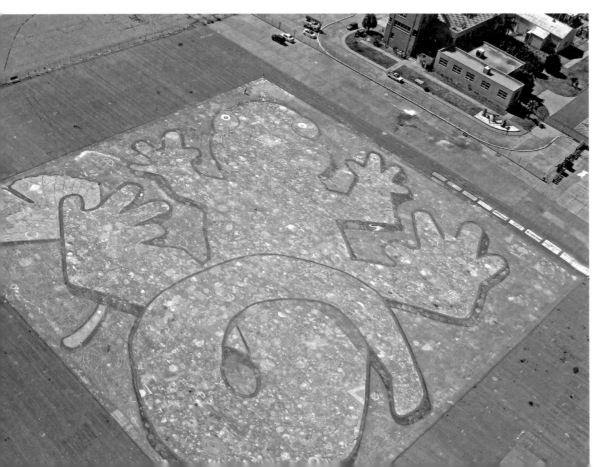

Mark Wagner's Guinness World Record–winning painting was meant to be viewed from the sky. He contacted Google Earth, which photographed it for him when the painting was complete.

INTERACTIVE OPPORTUNITIES

Three-D artists work around the premise of incorporating activity into their works, so that the public can more fully engage in the composition they have created.

Inviting the public to enter into the painting to "complete" it in some way provides a direct connection between the viewer and the artwork. The ability to play in the painting eliminates the distance between the art and the viewer, who actually becomes a component of the work. It's almost as if these paintings were waiting for their missing puzzle piece, which is anyone and everyone! That's the beauty of the interactive component—every single individual who interacts with or in the art creates a unique experience all his or her own. It's almost as if the painting were custom tailored for each person who enjoys it!

Since this is a chalk medium, one would think that inviting viewers into the art would be problematic, with chalk being marched all over the painting, which would ruin the work. This is definitely a consideration; however, if the artist is clever with the design and materials, he or she can create a work that minimizes the damaging elements of viewer interaction. Perhaps create a path or walkway using the existing surface of the street, thus eliminating the need for chalk in these trafficked areas. Or use a tempera color in the area where people will stand, as this does not rub off so easily with foot traffic and there is no need to worry about chalk sticking to shoes. Or keep the viewer interaction spot to the edges of the work, where the painting at the center can be viewed without disturbance. It's really up to the artist and his or her imagination, but as we can see, there are options to choose from.

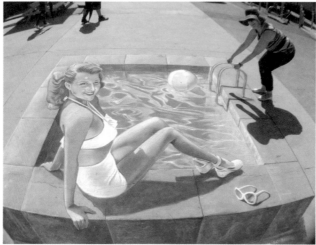

A swimming pool invites participants to take a dip.

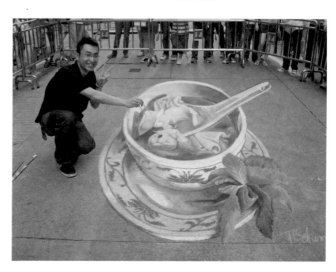

This bowl of wonton soup looks too good to pass up. Artwork by Tracy Lee Stum.

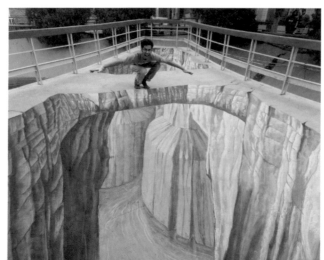

Here I used the existing pavement to create a bridge, easily allowing participants to enter into the painting without damaging the art.

WHEN ALL IS SAID AND DONE

Rain may come, people may walk on the art (in fact, it's guaranteed that they will!), cars may drive over it—that's what usually happens to a street painting. It seems kind of sad to know that a lovely portrait or illusion just created may be relegated to the soles of people's shoes.

The most difficult thing about street painting may be the ability to walk away from your work. You've just created something in extreme working conditions and have some beat-up fingertips to prove it. How can you simply walk away from it and leave it to the elements?

I think that most street painters feel a bit of separation anxiety when they make their first painting, I know I did! We are so conditioned to hold on to the physical in life, and in art, by making things that we can touch—paintings, drawings, sculptures,

and so on. It can be quite challenging for traditionally minded artists to realize that their work is going to vanish rather quickly and disappear forever. Even with photographs taken to capture the image forever, it is not quite the same. The street painting has a "life" to it while it's being created that's extremely difficult to capture on film. It evolves and transforms with each mark made. It reflects the creative soul of the artist making it, which is a very rare and priceless experience for all who witness this process.

Ultimately, we are left with the ability to release attachment to our creations, and perhaps, more importantly, learn to embrace that which we have within us—the ever-present ability to create anew, to use the lessons and gifts we have learned in the process to continue on our path of exploration and self-discovery. To share

our thoughts, feelings, sensations, and ideas about the world around us, to the world around us.

Cuboliquido sums it up this way: "The uniqueness that I instead try to share with the viewer is the model or the moment that I choose to play. If then, thanks to the image produced, other people may perceive this uniqueness, sharing becomes a way to exchange culture, knowledge, and mutual growth."

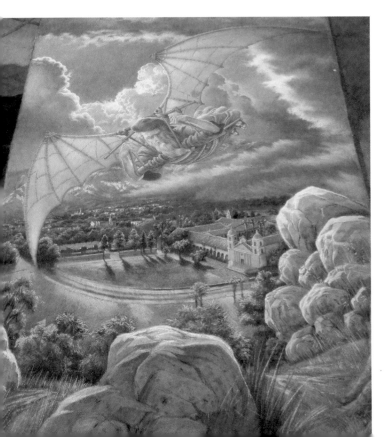

This wonderful design depicting Leonardo da Vinci, high in the sky on one of his flying machines, was created by Phil Roberts.

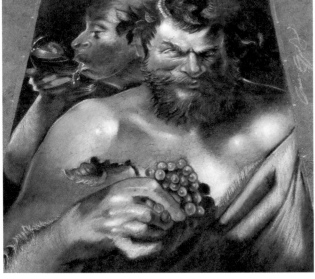

Artist Ever Galvez demonstrates his mastery of classical imagery on pavement with this copy of Peter Paul Ruben's 'Two Satyrs'.

MAKING YOUR OWN PASTELS

Making your own pastels can be a rewarding and gratifying activity, which can save money in the long run. While the process may seem a bit involved, the benefits are surely worth the effort. You'll have highly pigmented pastels with minimal binder and a customized color palette suited to your particular working needs.

Good-quality dry pigments and binding solutions are central to making good-quality homemade pastels. A proper binding solution takes some time to achieve but will yield good results later on, so plan to pay close attention to your process. Gum tragacanth is a binding agent that is activated when mixed with water. Methylcellulose, which is suitable in cold water mixtures, has also been used as a substitute for tragacanth. Various degrees of tragacanth solutions can be used for various pigments, so keeping a journal of recipes and mixtures is advised.

Note your material sources and dates purchased as well, because different batches may work differently with various mixtures. Keeping a systemized method to making your own pastels can take the guesswork out of which binder works best with each pigment. Keep a logbook of your recipes and note the pros and cons of each batch—anything to help you fine tune your recipes. Pigment batches can vary quite a bit; however, having a log to refer to will help move the process along a little more efficiently.

To prepare homemade pastels, you will need:

- Glass slab
- Gum tragacanth
- Distilled water
- 4 pint-size glass jars with lids
- Dry pigments
- Precipitated chalk (calcium carbonate)
- Latex gloves, to wear when rolling pastels
- Wide palette knife (or pastry spatula)
- Wax paper
- Newsprint paper
- Dust mask

MIXING THE GUM TRAGACANTH SOLUTIONS

Solution A

- Cold distilled water - 8 fluid ounces (235 ml)
- Gum tragacanth - ⅓ ounce (10 ml)

Solution B

- Solution A - 4 fluid ounces (120 ml)
- Cold distilled water - 8 fluid ounces (235 ml)

Solution C

- Solution B - 4 fluid ounces (120 ml)
- Cold distilled water - 8 fluid ounces (235 ml)

Solution D

- Solution C - 4 fluid ounces (120 ml)
- Cold distilled water - 8 fluid ounces (235 ml)

Solution E

- Solution D – 4 fluid ounces (120 ml)
- Cold distilled water – 8 fluid ounces (235 ml)

We make various solution strengths because different pigments require different binder ratios to work optimally. Stronger solutions may work well with some pigments but not others, which require weaker binding solutions. Each pigment will require different strength tragacanth solutions to produce the proper degree of softness. For instance, very few pigments will need the full-strength Solution A.

To begin with Solution A, place the ⅓ ounce of gum tragacanth into one of the glass jars and add the 8 ounces of cold distilled water. Shake well, and cover with lid, allowing the mixture to stand in a warm place overnight. The tragacanth will not dissolve but instead will form a gelatinous solution. Once set, this may be kept in the refrigerator to avoid spoiling.

Continue by following the ratios laid out for Solutions B, C, D & E and keep in separate jars.

MIXING THE PASTELS

Once you have your gum tragacanth solutions ready, you can begin mixing with your pigments to create your pastel sticks.

1. Start with white pastels by pouring out 3.5 ounces (100 g) of precipitated chalk onto your marble slab, creating a mound with a center well and then add 1.25 fluid ounces (37.5 ml) of Solution B into the center. Tip: Please be sure to wear a dust mask at this stage as particulates from pigments can be inhaled.

2. Mix with a wide palette knife or spatula on the glass slab until a smooth but firm dough is achieved. If the mixture is too dry or stiff, add more water. This is your white pastel stock. Form into a cylindrical cake but make sure you don't over work it. Tip: Make a large amount of the white pastel stock because you'll add it to other pigments later for lighter tones of various colors.

3. Cut the white pastel stock in half. Set aside one half of the white chalk for mixing with other pigments, covered with wax paper.

4. Cut off portions of the white pastel block that you can mold into sticks sized approximately 3" long x ¾" thick, however sizes can vary as needed. Roll between your palms just two or three times. Again, you don't want to over work this as it may cause binder to leach out of the surface. Put the sticks aside for drying (you may cover your pastels with wax paper to slow down the drying and ensure consistent quality).

5. Pour out about 4 ounces (120 ml) of a selected pigment (ultramarine, for example) and mix with a sufficient amount of Solution B to a consistency that won't adhere to the fingers. If the dough is too wet, it sticks to paper, so add a bit more pigment; and if it's too dry the pastels will fall apart before they dry, so add a little more binder.

6. Form this mixture into a cylindrical cake, cut that mixture in half, make sticks from it, and put aside for drying. Use the remaining half to mix with your white chalk, using the palette knife.

7. Repeat this process, continuing to cut the remaining color with an equal amount of the white pastel stock, until it reaches its limit of paleness. Now you have a complete range of one color!

8. Allow the pastel sticks to dry on newsprint paper for a few days to one week before use. The slower they dry, the less chance they will break—they are best when they can dry out naturally. Tip: Change the paper periodically until all the moisture has evaporated from the pastel sticks.

This process can be done in reverse, with each additional section being added to a pure pigment dough to create a scale going toward full-strength color.

A variety of homemade chalk pastels made by artist Alice Scott Crittenden.

USING MOLDS

Some artists prefer to use a mold for their pastel sticks. After the initial rolling, they press the dough into premade molds that will yield an even stick; 3 by ½-inch (7.6 by 1.3 cm) mold indentions work very well for this.

IRIDESCENT AND METALLIC PIGMENTS

Alice Scott Crittenden also recommends adding iridescent and metallic pigments to this recipe, creating a chalk pastel with some subtle dazzle.

RECOMMENDED SOLUTIONS

Here is a list of recommended gum tragacanth solutions for the range of pigments you might use. See the Resources (page 155) for a list of pigment suppliers.

Solution A (strongest solution)

- Cadmium reds

Solution B

- Precipitated chalk
- Titanium white
- Vermillion
- Alizarin crimson
- Ultramarine blue
- Cobalt blue
- Burnt umber

Solution C

- Mars black
- Mars red
- Cerulean blue
- Cadmium yellows
- Chromium green oxide

Solution D

- Burnt sienna (* 1 part + 1 part kaolin)
- Raw sienna
- Ivory Black
- Mars violet
- Phthalocyanine Blue (* 3 parts + 1 part kaolin)
- Phthalocyanine Green (* 3 parts + 1 part kaolin)
- Manganese Violet

Solution E (weakest solution)

- Indian red
- Yellow Ochre
- Viridian
- Raw umber

STREET PAINTING FESTIVALS

UNITED STATES

Art Along the Rogue (Grants Pass, OR): artalongtherogue.com

ArtHaus Street Painting Festival (Port Orange, FL): arthaus.org

Arts Alive (Mission Viejo, CA): cityofmissionviejo.org/artsalivefestival

Autism Chalk Art Family Festival (Covina, CA): autismchalkart.com

Belmont Shores Sidewalk Chalk Art Contest (Belmont Shores, CA): justinrudd.com/chalk

Bloom N Chalk Fest (Safety Harbor, FL): bloomnchalkfest.com

Burbank Arts Festival (Burbank, CA): burbankartsforall.org/community/downtown-burbank-arts-festival

Carlsbad Artsplash (Carlsbad, CA): facebook.com/CarlsbadArtSplash

Chalk & Walk (Kansas City, MO): kcchalkandwalk.org

Chalk 'n Rock (Bigfork, MT): chalknrock.org

Chalk About it! (Dayton, OH): lifeessentials.org/chalk-about-it

Chalk Alive (Vista, CA): vistastrawberryfest.com/strawberry-festival-contests/chalk-alive

Chalk and Chocolate Festival (Petoskey, MI): crookedtree.org/chalk-chocolate

Chalk Art (Naples, FL): pelicanbayrotary.com/chalk_art

Chalk Block (Fort Myers, FL): artfestfortmyers.com/chalk-art

Chalk It Up (Sacramento, CA): chalkitup.org

Chalk It Up for Art (Coral Springs, FL): coralspringsmuseum.org/chalk-it-up-for-art

Chalk it up! (Hendersonville, NC): narniastudios.com/chalk_it_up.htm

Chalk it up! (Prescott, AZ): prescottchalkart.com

Chalk the Walks: chalkthewalks.com

ChalkFest (Twentynine Palms, CA): action29palmsmurals.com/events.html

Chalkfest (Wausau, WI): wausauevents.org/chalkfest

Clearwater Chalk Walk (Clearwater, FL): clearwaterbeachchalkwalk.com

Cleveland Museum of Art Chalk Festival (Cleveland, OH): clevelandart.org/events/special-events/chalk-festival

Community Mosaic Street Painting Festival (Riverhead, NY): eastendarts.org/programs/community-mosaic.html

Denver Chalk Art Festival (Denver, CO): larimerarts.org

Dogwood Arts Festival Chalk Walk (Knoxville, TN): dogwoodarts.com/chalk-walk

Drawing up Central (Albany, NY): anth559.wix.com/drawing-up-central

Eau Gaille (Melbourne, FL): artworksofeaugallie.org

Elmira Street Painting Festival (Elmira, NY): elmirastreetpaintingfestival.org

Gasparilla Festival of the Arts (Tampa, FL): gasparillaarts.com

Gesso Italiano (San Diego, CA): littleitalysd.com/events/little-italy-festa/gesso-italiano/

Hudson Valley Chalk Festival (New Paltz, NY): hudsonvalleychalkfestival.com

I Madonnari Festival (Santa Barbara, CA): imadonnarifestival.com

Italian Street Painting Marin (San Rafael, CA): italianstreetpaintingmarin.org

Jupiter Jubilee (Jupiter, FL): jupiter.fl.us/index.aspx?NID=158

Key West Chalkfest (Key West, FL): artinpublicplaceskw.com/chalkfest

Luna Park Chalk Art Festival (San Jose, CA): lunaparkchalkart.org

Marietta Chalktober Fest (Marietta, GA): chalktoberfest.com

North Beach Festival (San Francisco, CA): sf.funcheap.com/annual-north-beach-festival

Palatka Chalk Explosion (Palatka, FL): artsinputnam.org/event2

Palo Alto Festival of the Arts (Palo Alto, CA): mlaproductions.com

Pasadena Chalk Festival (Pasadena, CA): pasadenachalkfestival.com

Paseo Pastel (St. Augustine, FL): staugustinechalkwalk.com

Pastels on the Plaza (Arcata, CA): ncsheadstart.org/events/227-2

Pastels on the Plaza (Chico, CA): chicorec.com/Community-Events

Perry Chalk Art Festival (Perry, NY): insitearch.com/perrychalkfestival

Pomona Chalk Art Festival (Pomona, CA): downtownpomona.org/events/chalk-art-festival

Redondo Beach Chalk Art Festival (Redondo Beach, CA): redondopier.com/event/chalk-art-festival

Sarasota Chalk Festival (Venice, CA): chalkfestival.org

Sidewalk Chalk Art Festival (Forest Grove, OR): valleyart.org/chalk-art-festival

SparkCon Arts Festival (Raleigh, NC): sparkcon.com

Spring Fever in the Garden (Wintergarden, FL): springfeveringarden.com

St. Johns River Festival of the Arts (Sanford, FL): stjohnsriverartfest.com/chalk-art

Street Painting Festival (Lake Worth, FL): streetpaintingfestivalinc.org

Suncoast Arts Fest (Wesley Chapel, FL): suncoastartsfest.com

Sweet Chalk Festival (Lockport, NY): sweetsweetsummer.com

Temecula Street Painting Festival (Temecula, CA): temeculaevents.org/streetpainting

Top of the Lake Art Fest (Okeechobee, FL): okeechobeemainstreet.org/p/23

Uptown Art Expo (Altamonte Springs, FL): uptownartexpo.com/?page_id=21

Ventura Art & Street Painting Festival (Ventura, CA): venturaartfestival.com

Via Arte Italian Street Painting Festival (Bakersfield, CA): viaartebakersfield.com

Via Colori Street Painting Festival (Bardstown, KY): viacolorikentucky.com

Via Colori Street Painting Festival (Houston, TX): centerhearingandspeech.org/via-colori

Via dei Colori SLO (San Luis Obispo, CA): viadeicolorislo.com

INTERNATIONAL

Bella Via Festival (Monterey, Mexico): bellavia.mx

Blumberg Street Art Festival (Blumberg, Germany): street-art-festival.de

STREET PAINTING FESTIVALS

continued

LIST OF CONTRIBUTORS

Cambridge Street Art Festival (Cambridge, Canada): cambridgestreetartfestival.com

Chalk Urban Art Festival (Sydney, Australia): chalkurbanart.com

Colores de Jalisco (Jalisco, Mexico): facebook.com/coloresdejalisco

Dubai Canvas (Dubai, UAE): dubaicalendar. ae/en/event/events/dubai-canvas.html

Expressions in Chalk (London, Canada): expressionsinchalk.org

I Madonnari International Street Painting Festival (Alatri, Italy): imadonnarifestival.com

Incontro Nazionale dei Madonnari (Mantova, Italy): centroitalianomadonnari.it

International Festival de Street Painting (Toulon, France): festival-streetpaintingtoulon.jimdo.com

International Street Art Festival (Wilhelmshaven, Germany): streetart-wilhelmshaven.de

Internazionale dei Madonnari (Nocera Superiore, Napoli, Italy): concorsomadonnari.it

James Carling Street Painting Festival (Liverpool, United Kingdom): urbancanvas.org.uk

Malta Street Art Festival (Sliema, Malta): facebook.com/maltastreetartfestival

Monastir International Art Festival (Monastir, Tunisia): facebook.com/events/1055139444503805

Mumbai Street Art Festival (Mumbai, India): st-artindia.org

Pastelizacija (Zagreb, Croatia): pastelizacija.com

Victoria International Chalk Art Festival (Victoria, Canada): victoriachalkfestival.com

World Street Painting Festival (Arnhem, Netherlands): worldstreetpainting.nl/en/world-streetpainting

Nate Baranowski
natebaranowski.com
121, 141

Mario Belmares
148

Gerald Boyd
geraldboyd.com
16, 54, 55, 58, 67, 69, 80, 81, 88, 89

Ryan Bradley
16, 58, 60, 70, 85

Vera Bugatti
verabugatti.it
21, 141

Chris Carlson
chriscarlsonart.com
108

Sharyn Chan
96, 119, 140

Jennifer Chaparro
amazingstreetpainting.com
139

Maggie Choate
chalktreatment.com
12, 28, 33, 34, 38, 47, 52

Alice Crittenden
119

Cuboliquido
cuboliquido.com
108, 113, 137

Nigel Eaton
customchalksigns.com
25, 46, 50, 51

Bruno Fabriani
92, 93

Ever Galvez
evergalvez.com
151

Vero Gonzalez
99

Ketty Grossi
artemisiadiketty.net
20, 133

Ann Hefferman
annheffermanart.com
101, 111, 138

Gary Huber
garyhuberart.com
14, 57, 60, 67, 82, 83, 84

Julio Jimenez
21, 109, 126

Takako Kurita
35, 42, 43, 44

Julie Kirk-Purcell
juliekirk.com
111, 143

Michael Las Casas
mvlc1.com
114, 115

Luigi Legno
97, 143

Kim Lordier
kimfancherlordier.com
15, 61, 71, 90

Susan Lyon
susanlyon.com
17, 59, 66, 68, 76, 77

Dania Mallette
thechalkchica.com
39, 48, 49

Sara Mordecai
threemoonsstudio.com
113, 147

Cuong Nguyen
icuong.com
17, 67, 72, 78, 79

Catherine Owens
chalkandink.com
10, 24, 26, 53

Gary Palmer
garypalmerart.com
110

Brendon Pringle
chalkartdesign.com
25, 32, 33, 40

Anton Pulvirenti
29, 38

Victor Puzin
victorpuzin.com
97

Obaid ur Rahman
106

Wayne Renshaw
wr-architect.com/imad
115, 121, 127

Cheryl Renshaw
wr-architect.com/imad
115, 127

Phil Roberts
philroberts.com
111, 140, 151

Adry del Rocio
adrydelrocio.blogspot.com
97, 100, 147

Douglas Rouse
rouse66.com
112

Tomoteru Saito
tomoteru.web.fc2.com
134, 145

Valentina Sforzini
valentinasforzini.com
18, 94

Tracy Lee Stum
tracyleestum.com
8, 9, 18, 36, 37, 86, 87, 95, 96, 97, 98, 104, 106, 110, 116, 117, 124, 131, 176

Otto Stürcke
sturckestudio.com
14, 56, 63, 73, 74, 90

Jay Schwartz
101

Rod Tryon
19, 105, 132, 133

Mark Wagner
markwagnerinc.com
112, 113, 149

Bryce Widom
brycewidom.com
13, 22, 23, 27, 41, 45, 52

Gregor Wosik
www.klassiko.de
94, 112

Joel Yau
studioyau.com
20

Chris Yoon
11, 25, 39, 48

RESOURCES AND PHOTO CREDITS

Page 10: tanamachistudio.com, target
.com/bp/tanamachi+goods

Page 14: (Chalk) webexhibits.org/pigments,
wikipedia.org/wiki/chalk, (pastel) wikipedia
.org/wiki/pastel, (Chalk Drawings) www
.visual-arts-cork.com/drawing/chalk
-drawings.htm

Page 27: (Keith Haring) wikipedia.org/wiki/
Keith_Haring, (Dana Tanamachi) tanamachi
studio.com

Page 30: wikipedia.org/wiki/blackboard

Page 32: wikipedia.org/wiki/blackboard

Page 48: tnw.to/j4qhr, viralnova.com
/weekly-chalkboard-art/

Page 49 and 139: (Electro Pounce
Machine) mclogan.com/shop/electro
-pounce-machine-p-603.html, (Pounce
Pads) hancymfg.com/products.html

Page 59: artshow.com/apow/history.html,
collectorsguide.com/fa/fa071.shtml,
iapspastel.org/, metmuseum.org/toah/hd
/papo/hd_papo.htm, pastelartists.ca
/contents/history-of-pastel

Page 62: artworkessentials.com/products
/accessories/Viewfinder/VF68G.htm

Page 64: The Artist's Handbook of
Materials and Techniques: Fifth Edition,
Revised and Updated (Reference) by
Ralph Mayer

Page 66: (Pastel Paper & Board Brands)
Ampersand, Art Spectrum, Canson,
Clairefontaine, Dakota, Daler-Rowney,
Fabriano, Global Arts, Hahnemühle,
Multimedia Artboard, Pastel Velour,
PastelMat, Royal & Langnickel, Richeson,
Rives, Sennelier, Shizen, Strathmore,
UArt, Wallis

Page 69: (Vacuum easel) artistsnetwork.
com/the-artists-magazine/is-your-pastel
-studio-safe, (Easel Air Purifier) artistsair.
com/, (Studio Air Purifier source), foustco
.com/airpurifiers.html

Page 70: explore-drawing-and-painting
.com/painting-with-pastels.html

Page 71: artistsnetwork.com/medium
/pastel/plein-air-setup, artistsnetwork
.com/articles/art-demos-techniques
/plein-air-painting

Page 74: artworkessentials.com/products
/valuecomp/index.htm

Page 91: (Degas) blog.phillipscollection
.org/2011/12/21/degas-and-pastels-part-ii/,
http://degas-painting.info/degasstyle.htm,
(Framing Works) pastelsocietyofamerica
.org/index_thepastelmedium.htm,
mcbridegallery.com/pastelcareof.html

Page 99: (Screevers) screever.org/,
wikipedia.org/wiki/Jyoti_Bhatt

ACKNOWLEDGMENTS

This book would not exist without the talent and generous contributions of the artists featured. My sincere gratitude goes to each one of them for allowing me to speak their words and share their processes, which inspired me to offer a work that is hopefully informative, valuable and useful to those starting out on their own artistic journey.

Thanks to my patient editor, Joy Aquillino, for guiding me from being an overwhelmed newbie to someone who would consider doing this again in the future! To project manager John Gettings, art director Regina Grenier, and everyone at Quarry for this wonderful collaboration that I hope will inspire many would-be artists to jump right in!

In gratitude to all of those street painters, screevers and madonnari who came before me, paving the way for subsequent generations to practice and discover the magic of street painting. Thanks to my many peers, colleagues, teachers, friends and fans around the globe (there are so many—you know who you are!) who have inspired and encouraged me to keep working in this unorthodox manner, for which I am eternally grateful!

My path began with I Madonnari so thank you, Kathy Koury, for giving me my first pavement to work on and for maintaining one amazing event I am proud to call my home festival; to Sue and Joe Carlomagno for believing in me on my first work out of the gate! Thanks to Maryanne Webber, Rosy Loyola, Jeff Jones, Denise Kowal, and all the other many festival directors around the world who do this for the love of the art. I applaud you! And to the unsung heroes, the many festival photographers who make us look good.

Finally I need to thank my personal team / family, who have stood by me through all the many miles of pavement I've colored up: to Tim for introducing I Madonnari to me and for opening this extraordinary chapter of my life. To Justin for keeping me tethered to the here and now when needed and for encouraging me to pursue my wildest dreams. You are my anchor! To Sayak for demonstrating the beauty and joy of a shared vision and for teaching me about balance.

Last but not least thanks go to my dad, sisters and extended family for attending festivals whenever they could and for becoming my biggest street painting fans; and especially to my mom, Judy, for her unswerving support from my days of early crayon wall drawings. You saw my potential and helped foster it to its fullest.

Namaste!

ABOUT THE AUTHOR

Tracy Lee Stum began drawing as soon as she could clutch a crayon. She studied privately in her youth and earned a Bachelor's degree at Tyler School of Art/ Temple University, in Philadelphia. A trained painter and experienced muralist whose work can still be seen featured in luxury Las Vegas casinos, Tracy discovered street painting by accident and knew it was love at first sight!

Participating for more than a decade in numerous nonprofit street-painting festivals, Tracy transitioned her hobby into a full-time career in 2004 and hasn't looked back. Internationally recognized as a world-class street painter, Tracy added the Guinness World Record to her collection of vinyl for the Largest Chalk Painting by an Individual, in 2006.

Tracy currently delivers commissioned 3D and 4D works to Fortune 500 companies, international arts festivals, and the entertainment industry. She's painted at 2015's Super Bowl and India's famed "Durga Puja" Festival. A contributor on the 2013 Cannes Gold Lion award–winning team for their work in the now iconic Honda CRV "The Impossible Made Possible" commercial, Tracy also has a few TEDx talks on her personal street-painting journey under her belt. Her client list includes Breitling, Cadillac, IMAX, TNT, 20th Century Fox, and the Bank of East Asia.

A travel lover and passionate advocate for arts awareness and education, Tracy feeds her soul by participating as an arts envoy through the U.S. State Department, conducting 3D street-painting workshops in far-flung locales such as Thailand, Tajikistan, and India.

INDEX